# My Colorful Town
## A Coloring Tour

Chiaki Ida

# Introduction

When I was a little girl, I used to daydream about working in a shop. I would love to play "store" and pretend my dolls were customers. As children, stores are magical places, full of interesting objects, new sights and sounds, and endless possibilities for adventure.

Even as an adult, I still experience that same sense of wonder upon entering a new store for the first time. I tried to capture this feeling throughout these drawings. This coloring book will transport you to a city full of unique shops, cafés, and markets. A curious little girl will serve as your tour guide as you explore bakeries, antique stores, dress shops, and more.

I hope you enjoy visiting this picturesque little city and that you experience the same wonderful feeling of anticipation every time you flip the page and step inside a new store.

—Chiaki Ida

# Recommended Drawing Materials

### COLORED PENCILS
I recommend using colored pencils—they allow you to color both large areas and small details and are well-suited for beginners. For a hand-painted look, try using watercolor pencils.

### WATERCOLOR PAINT
When using watercolors, use water sparingly as too much liquid can cause the paper to wrinkle and warp.

# How to Color

1. Test out different colors on a piece of scrap paper to help decide your color scheme. If you don't like how a certain color looks, you can always cover it with a darker shade.

2. Once you've decided which colors to use, go ahead and get started coloring! Use a light touch and do your best to stay inside the lines.

3. Once you feel comfortable with the basic coloring technique, try some special effects, such as shading, blending, or adding patterns.

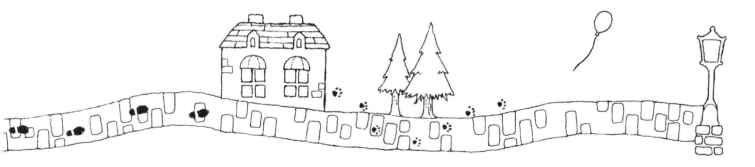

# Tips & Tricks from the Artist

- For a realistic look, use colored pencils to go back and add details to the drawings after they've been colored with watercolor paint. Just make sure the paint is completely dry first!
- If you're having trouble deciding on a color scheme, pick out one color you know you want to use and go from there. If I pick out light blue for the window frames, I know I'll want to use cream for the walls.
- Use shading and shadow to add depth. To create a shadow, continue using the same color pencil, but exert more pressure. You can also create a shadow using a blue or gray pencil. Use a white pencil or paint to create highlights.
- Remember, there are no rules when it comes to coloring. The ideas and tips on this page are just suggestions. Always use your favorite materials and techniques. The most important thing to remember is to have fun!

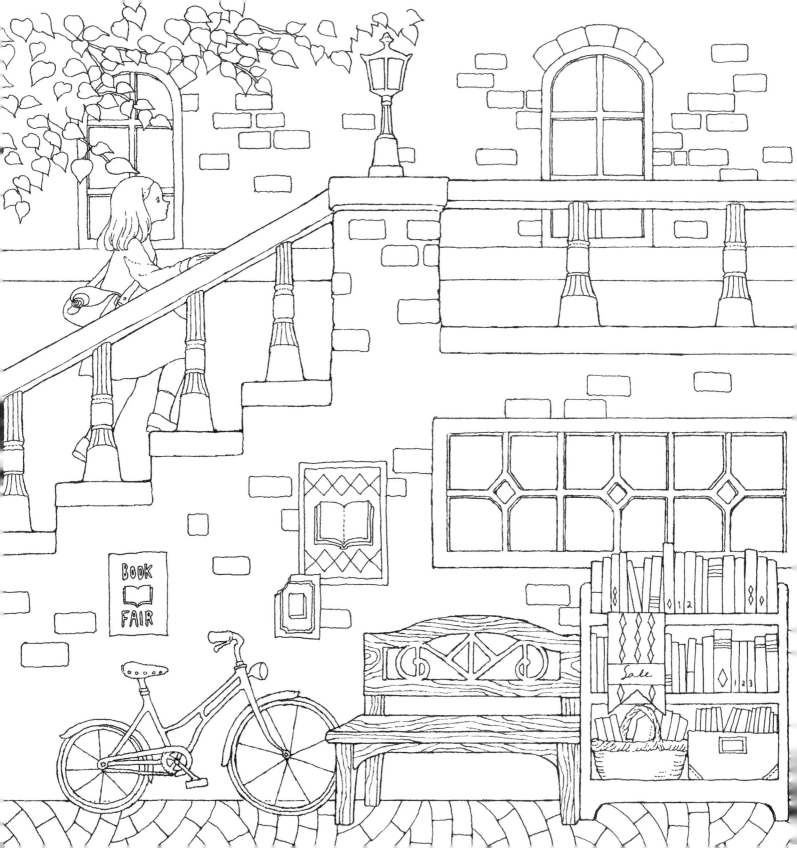

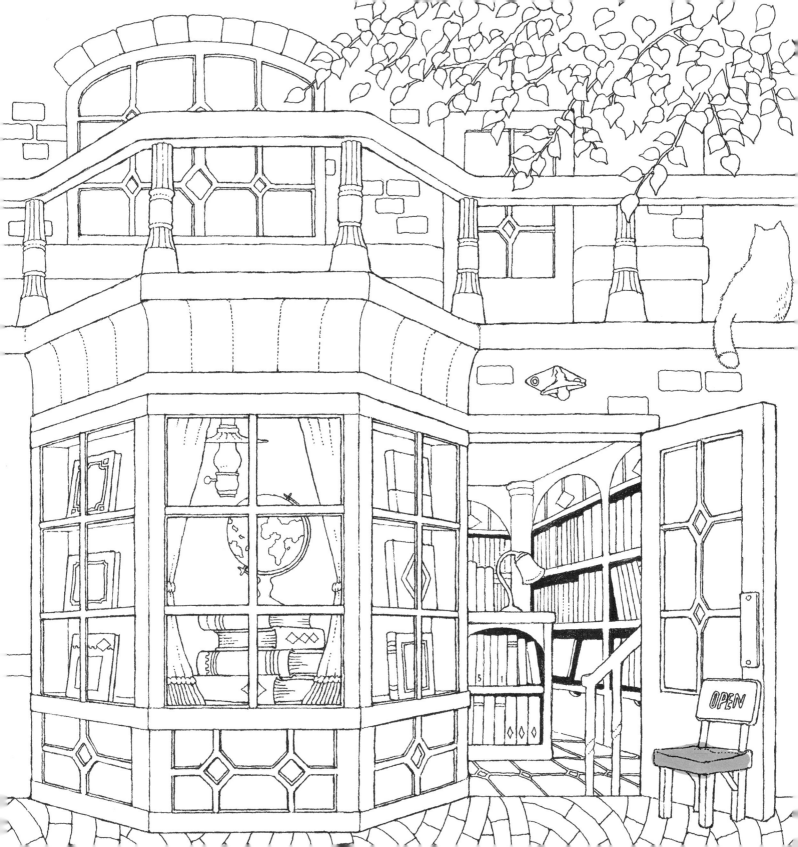

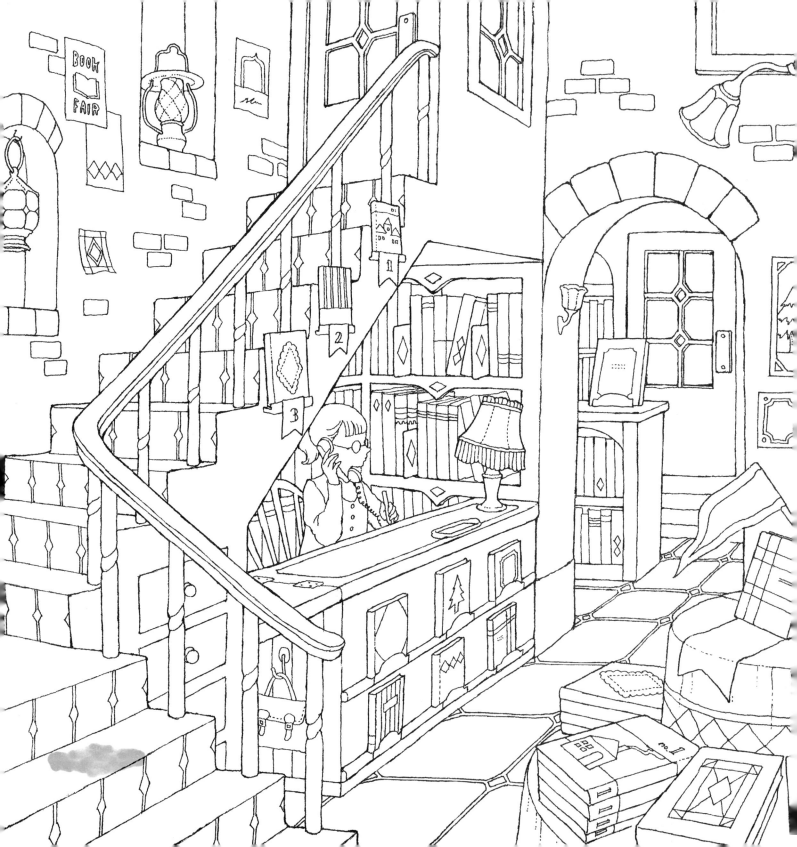

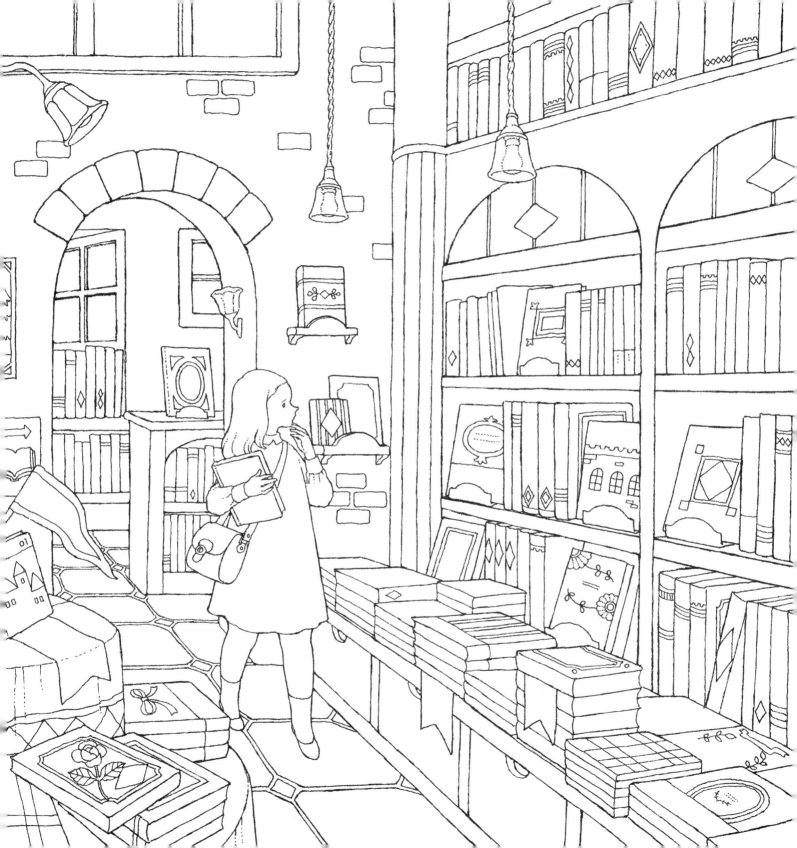

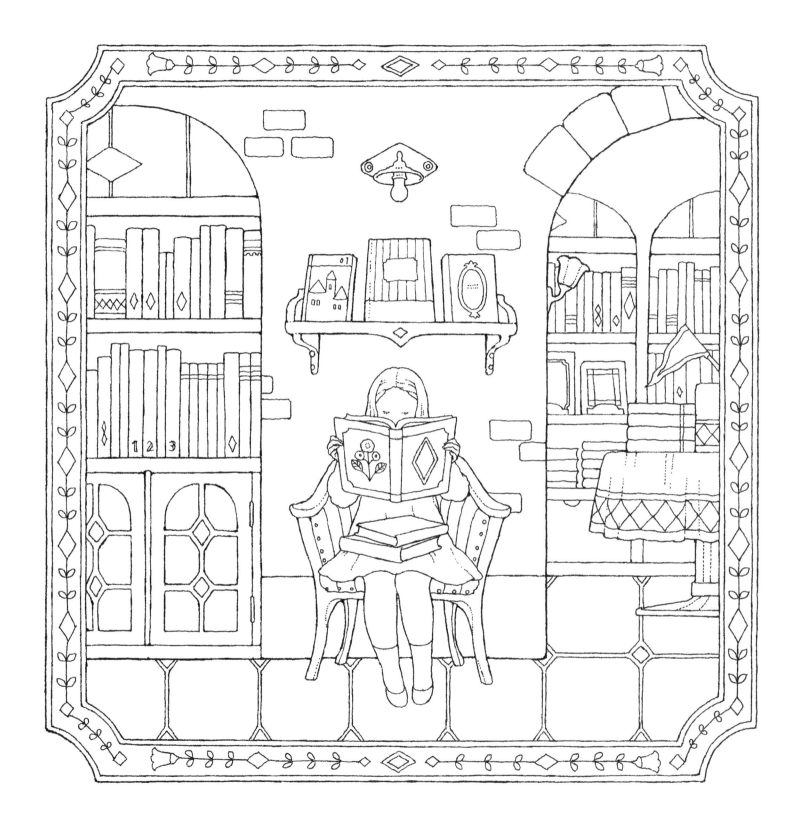

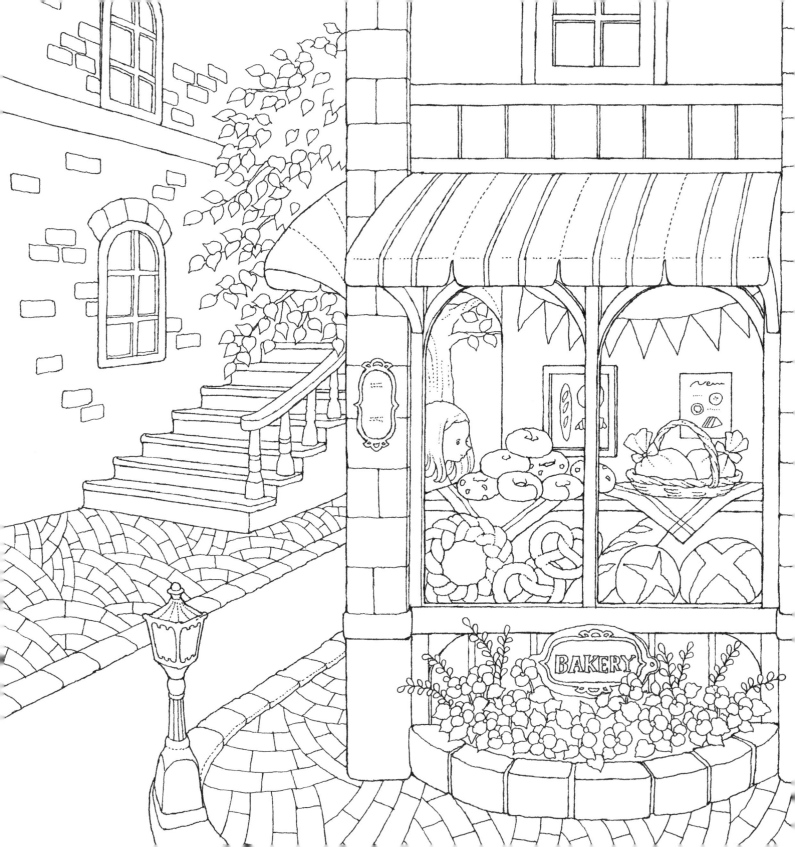

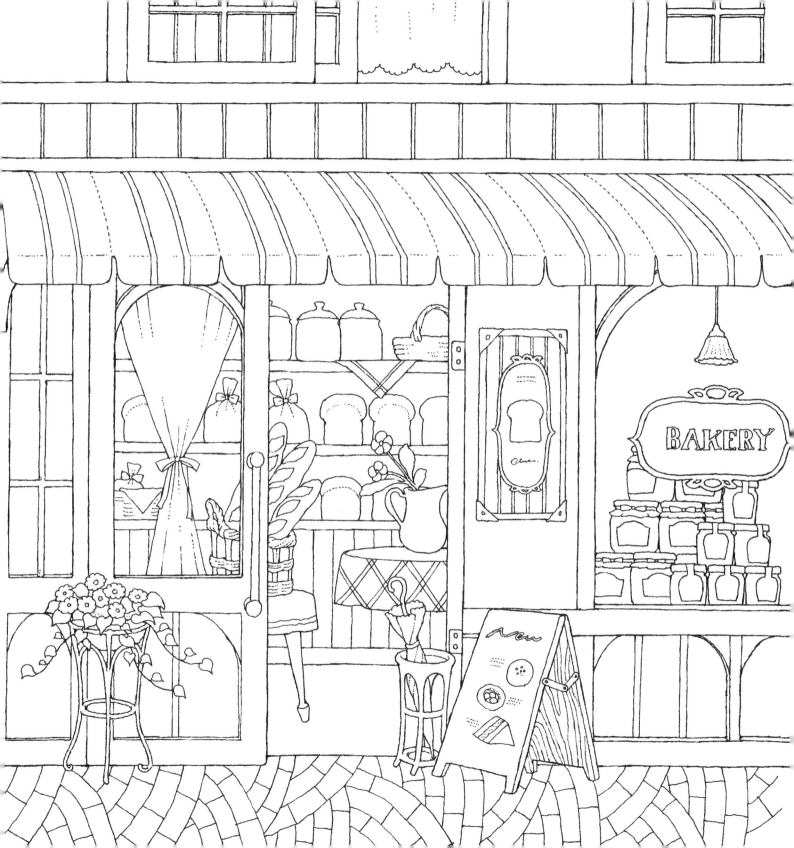

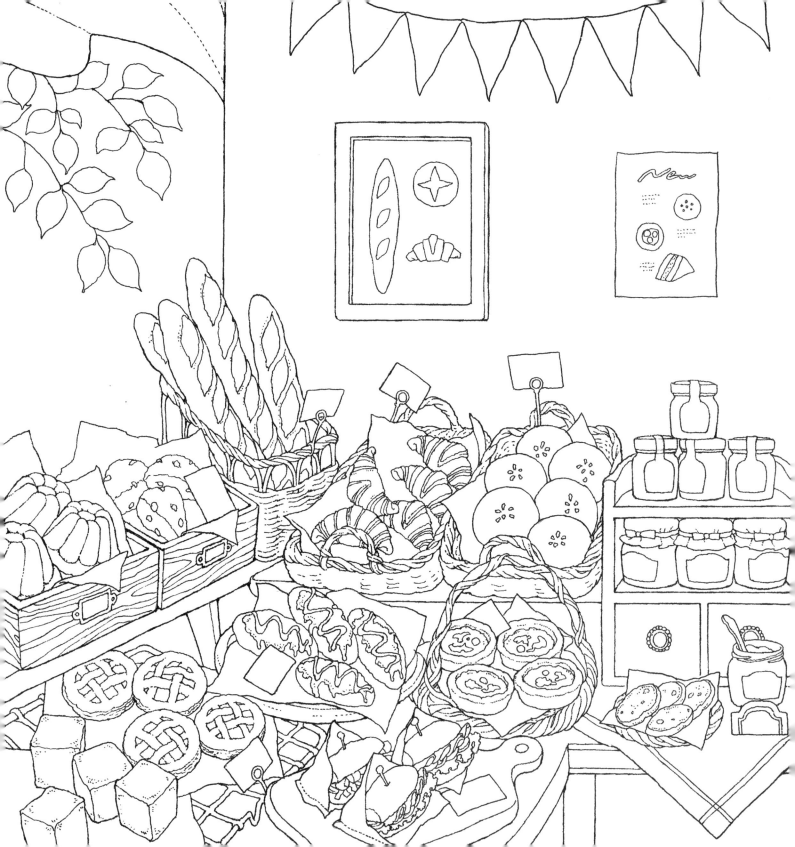

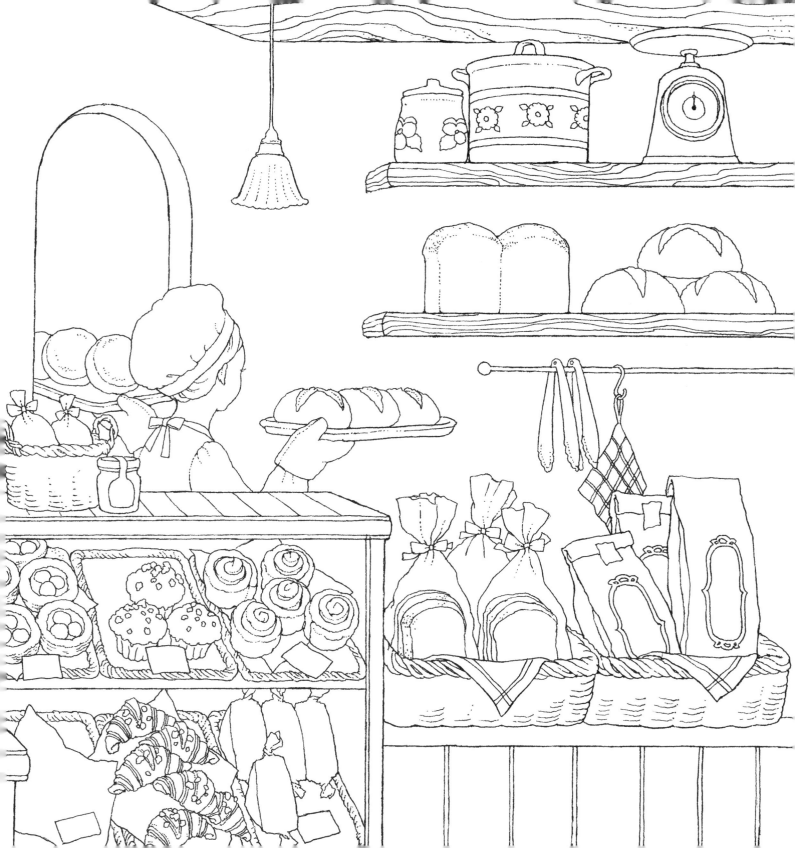

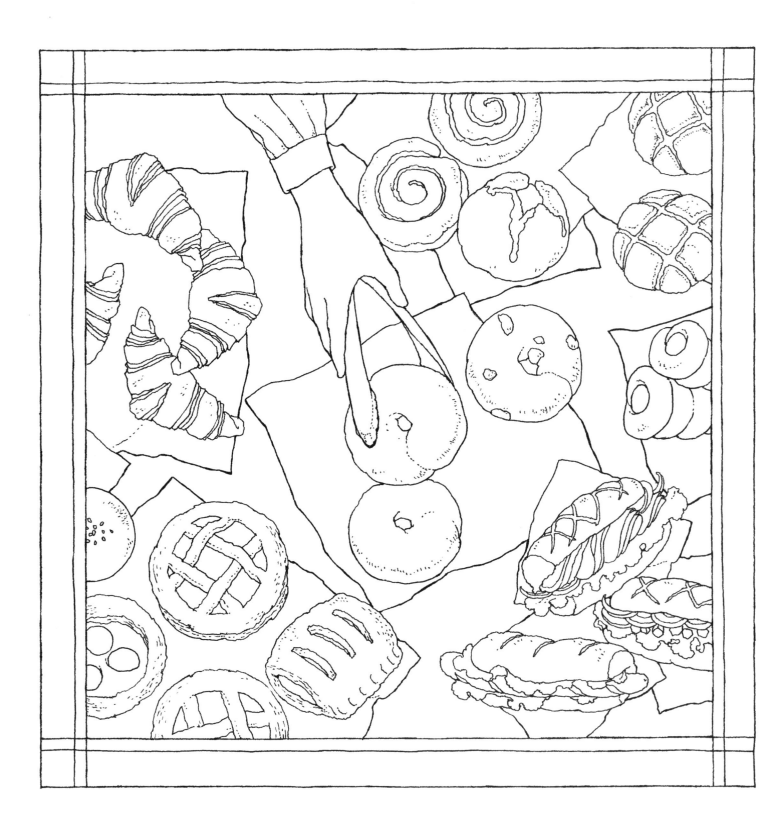

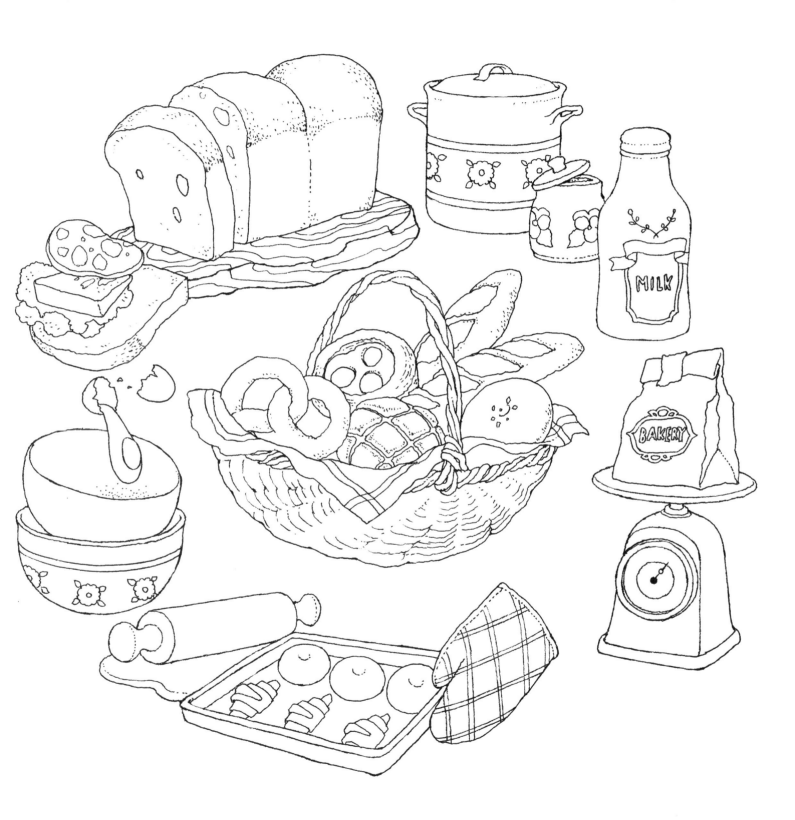

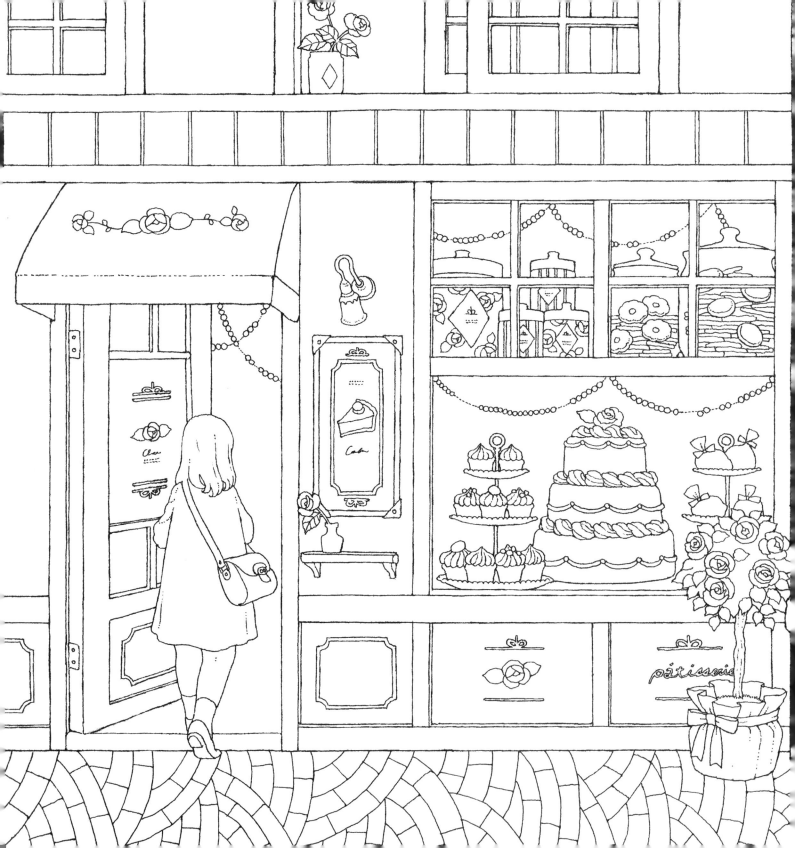

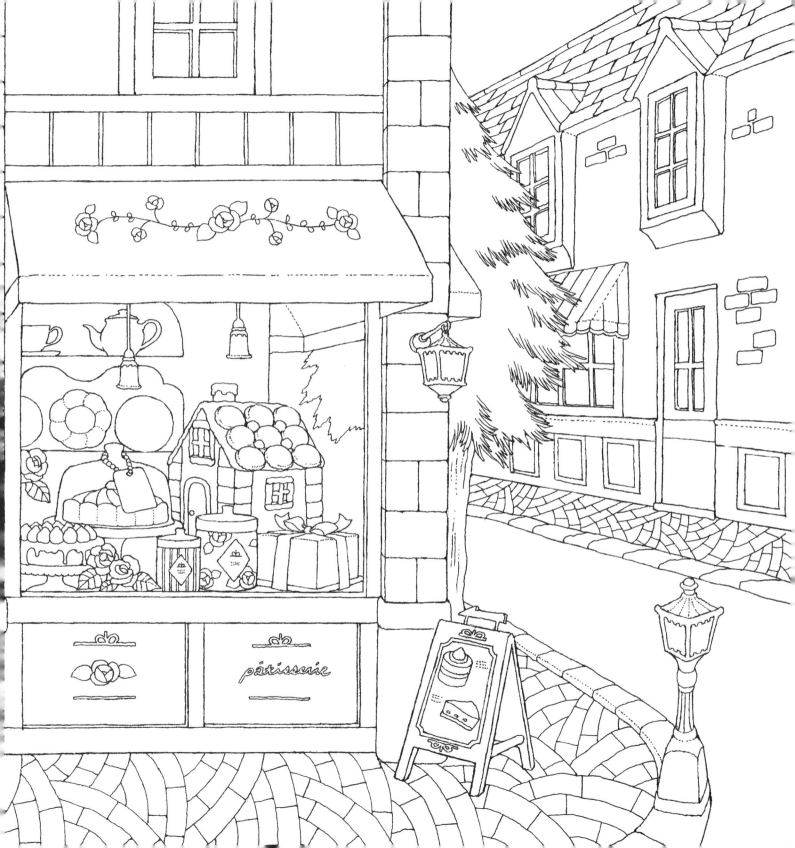

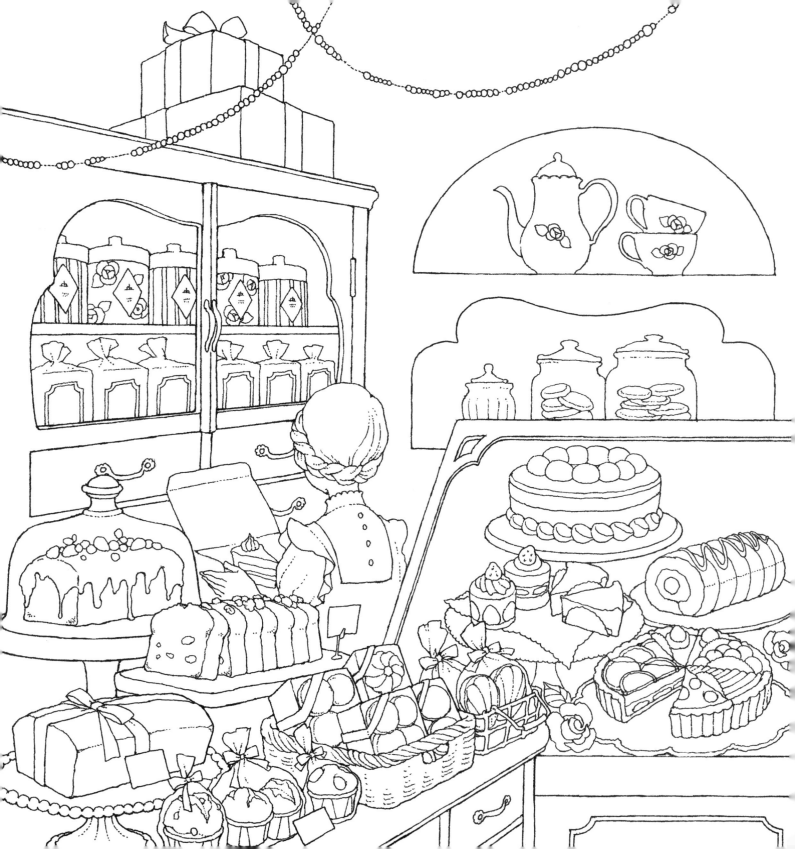

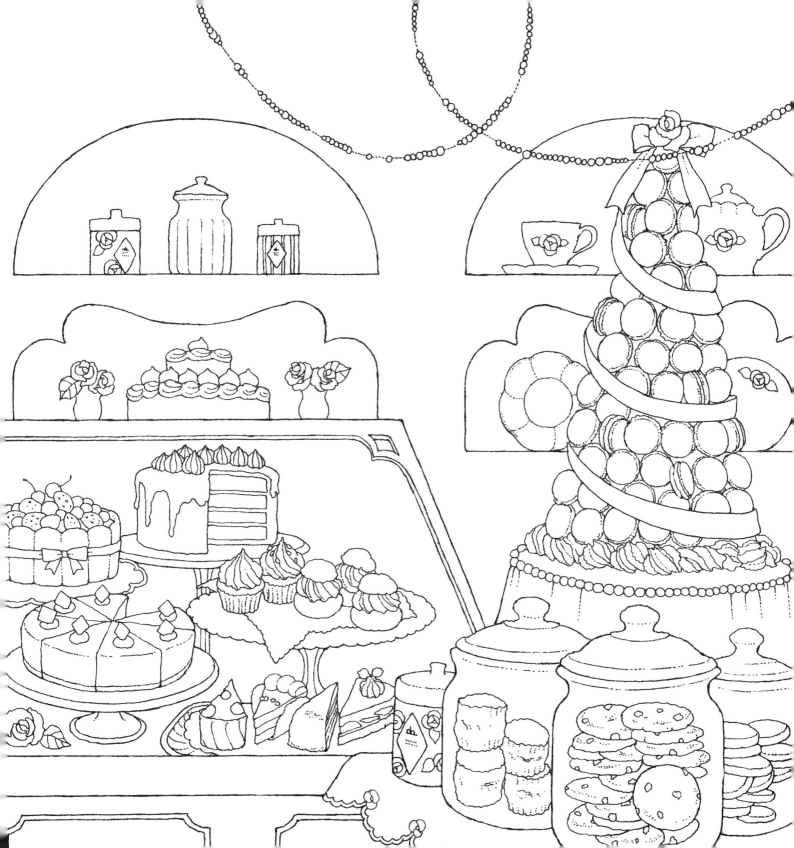

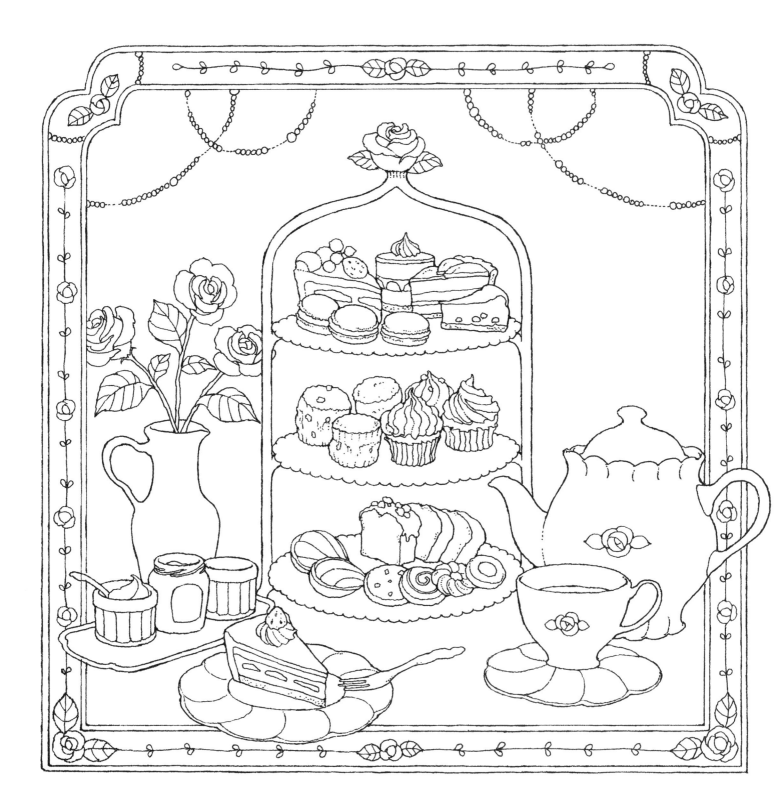

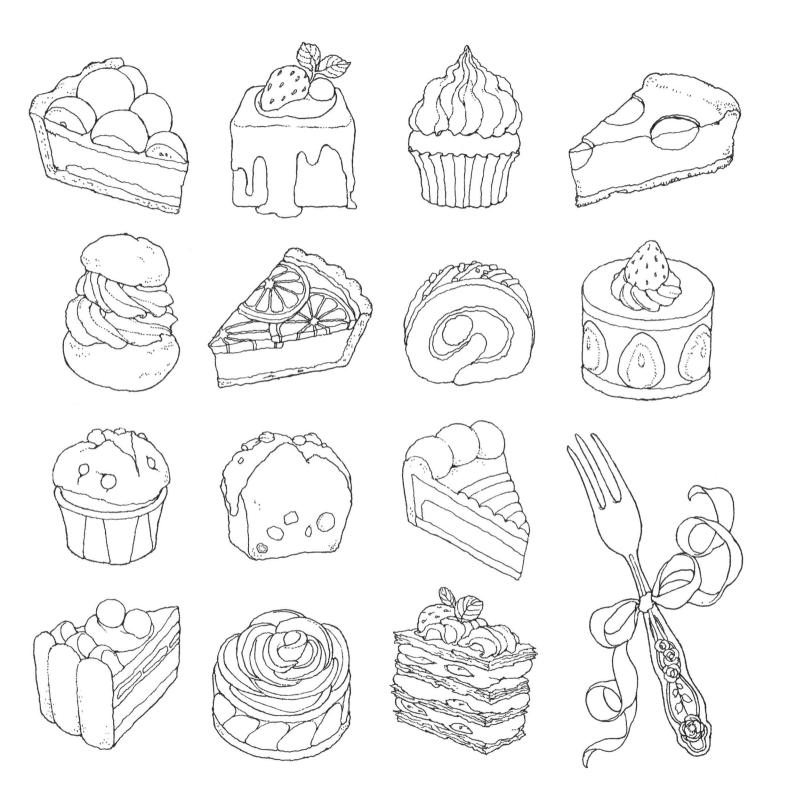

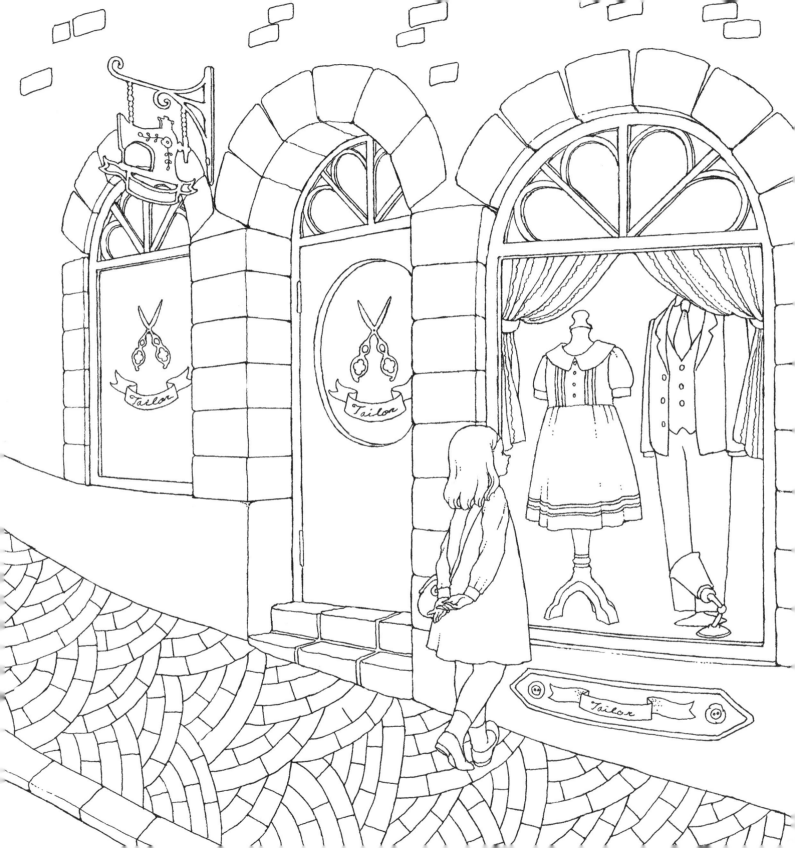

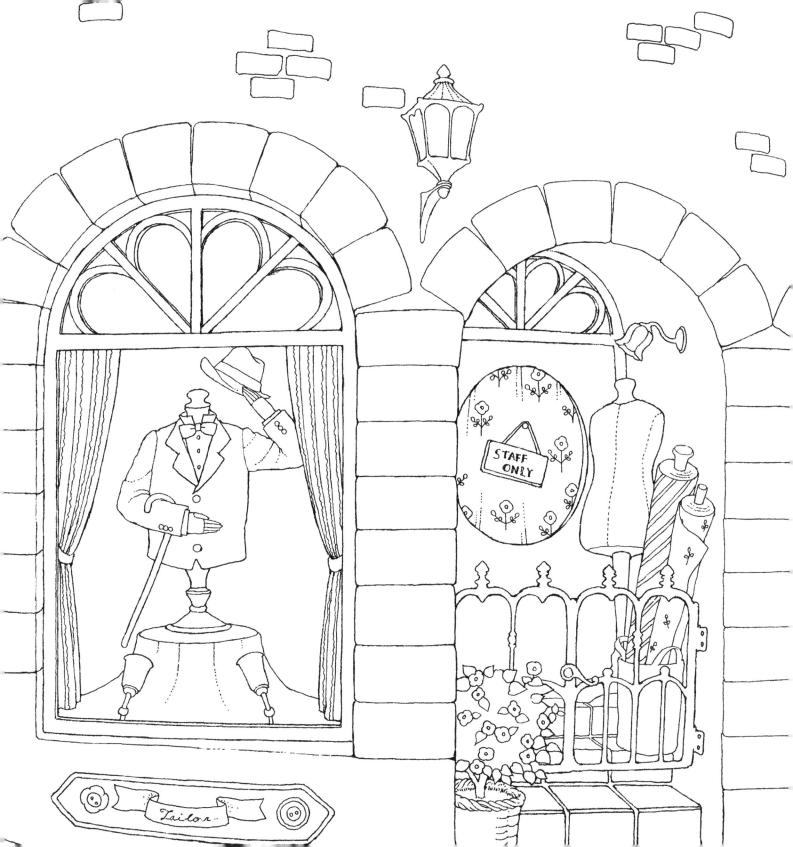

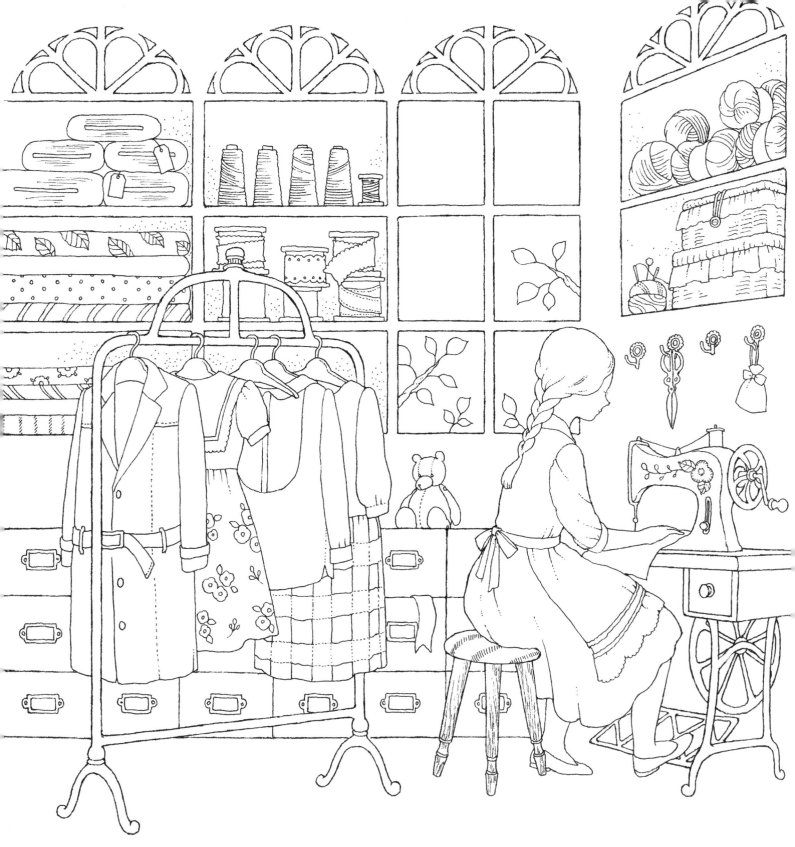

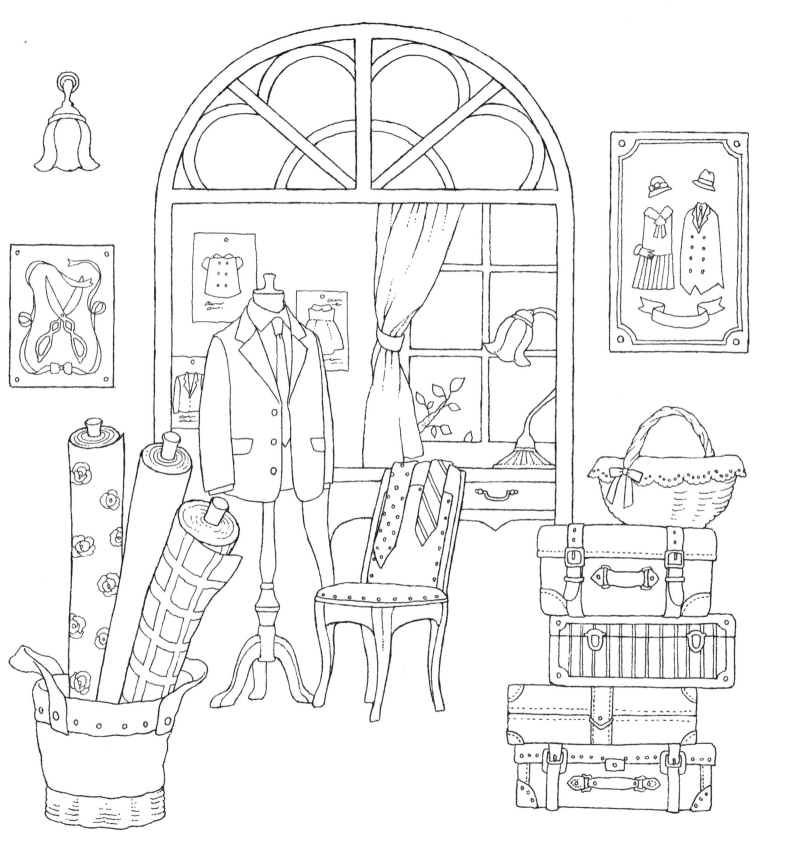

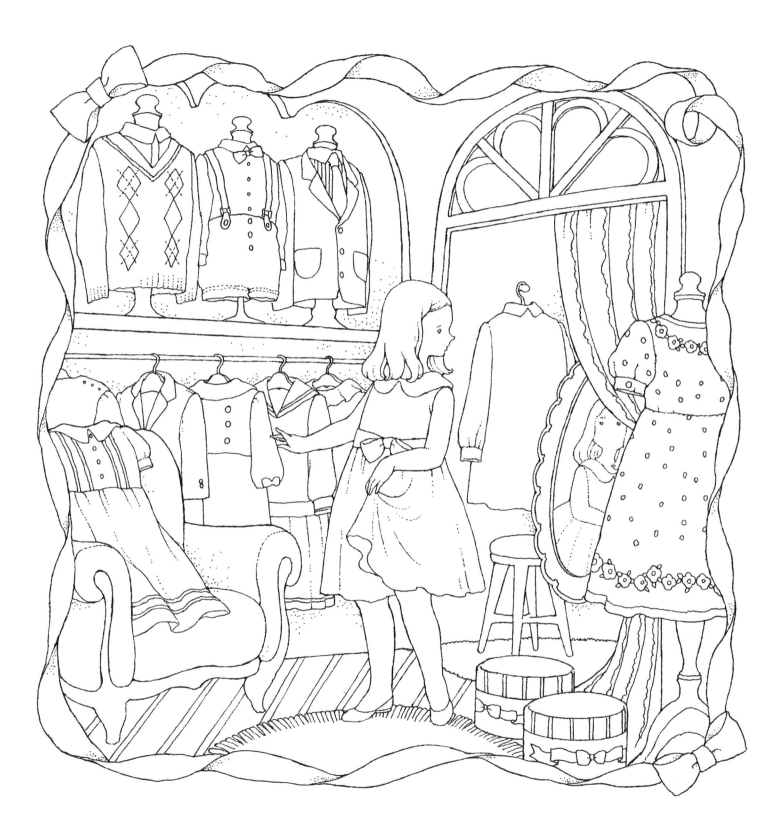

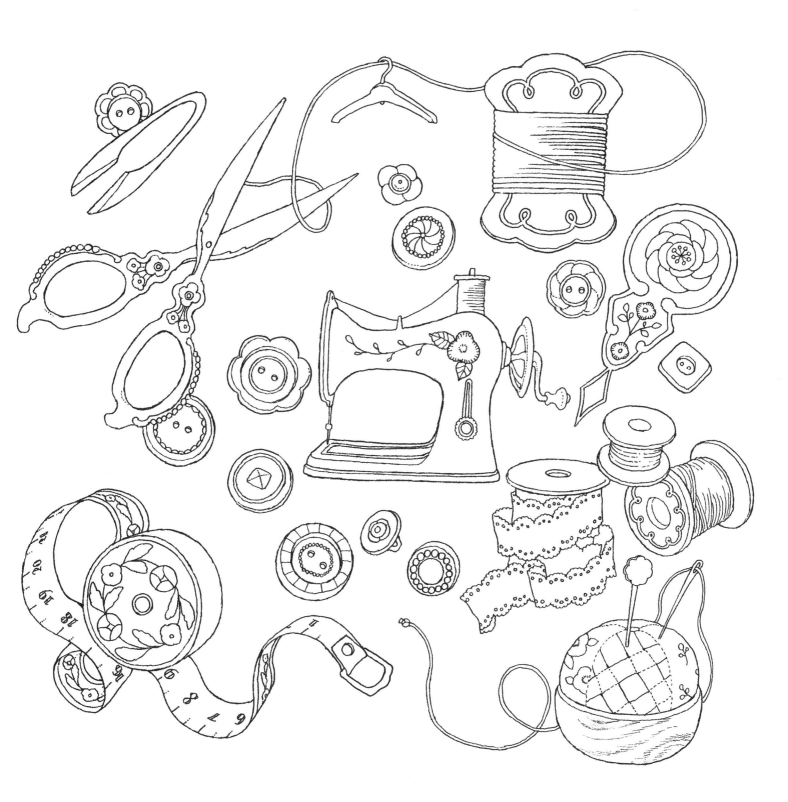

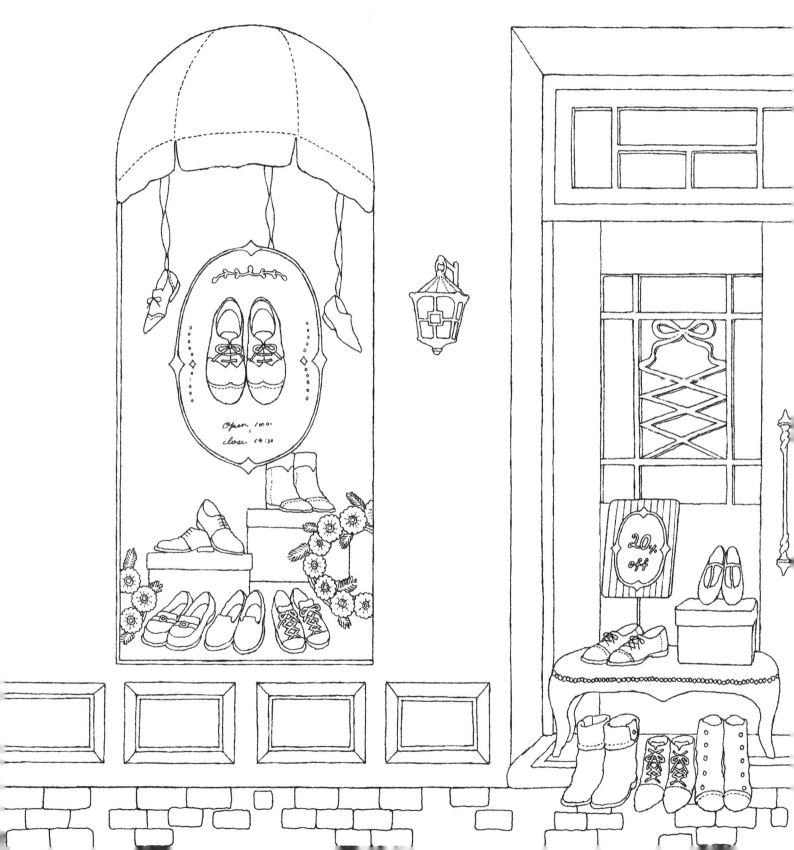

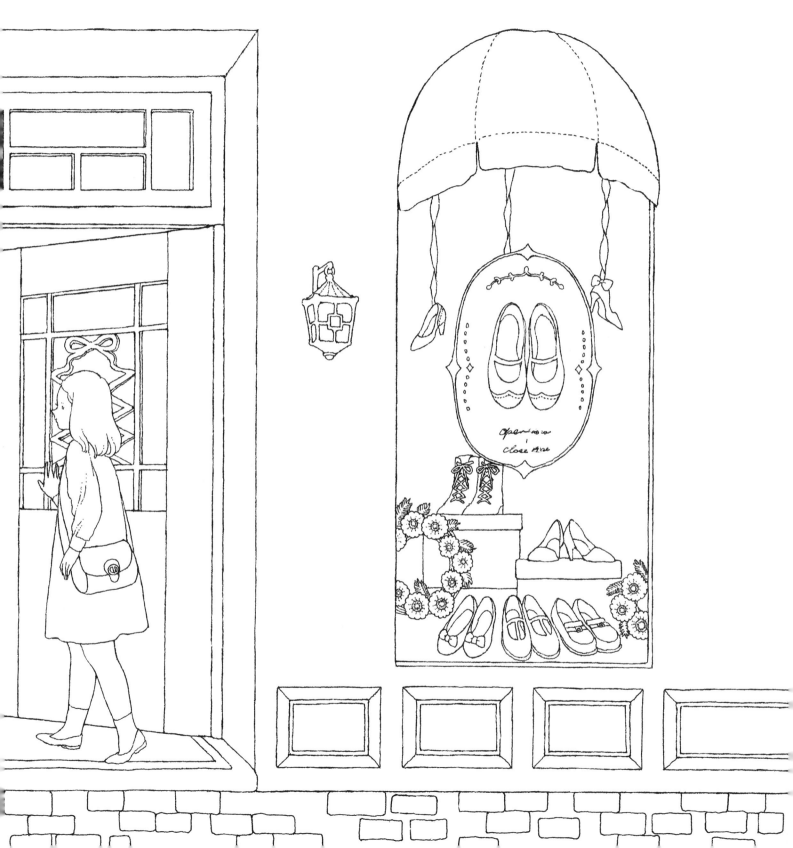

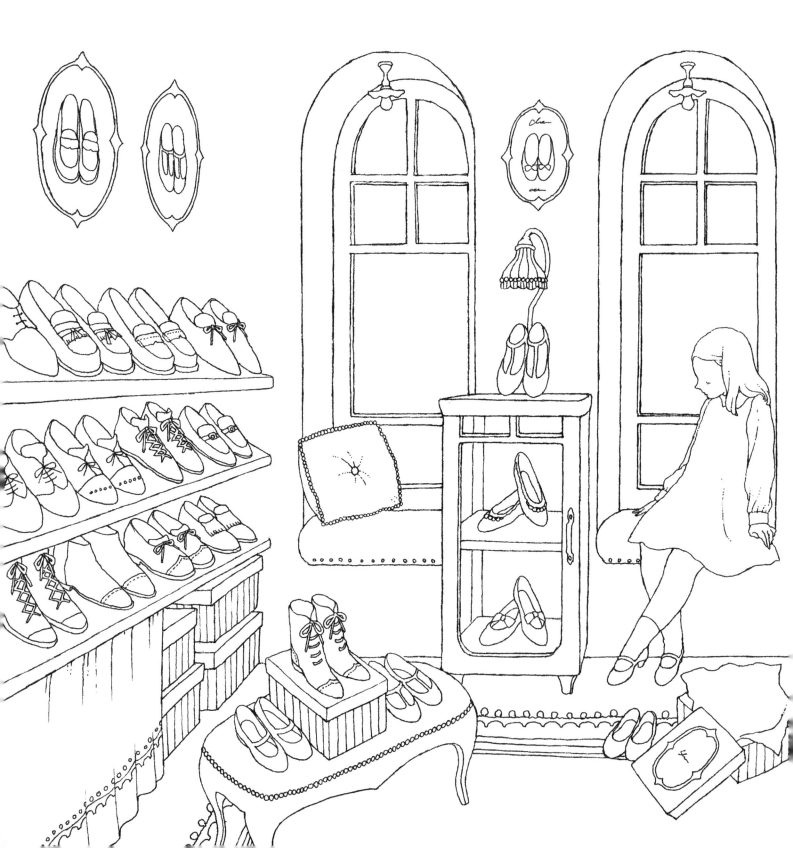

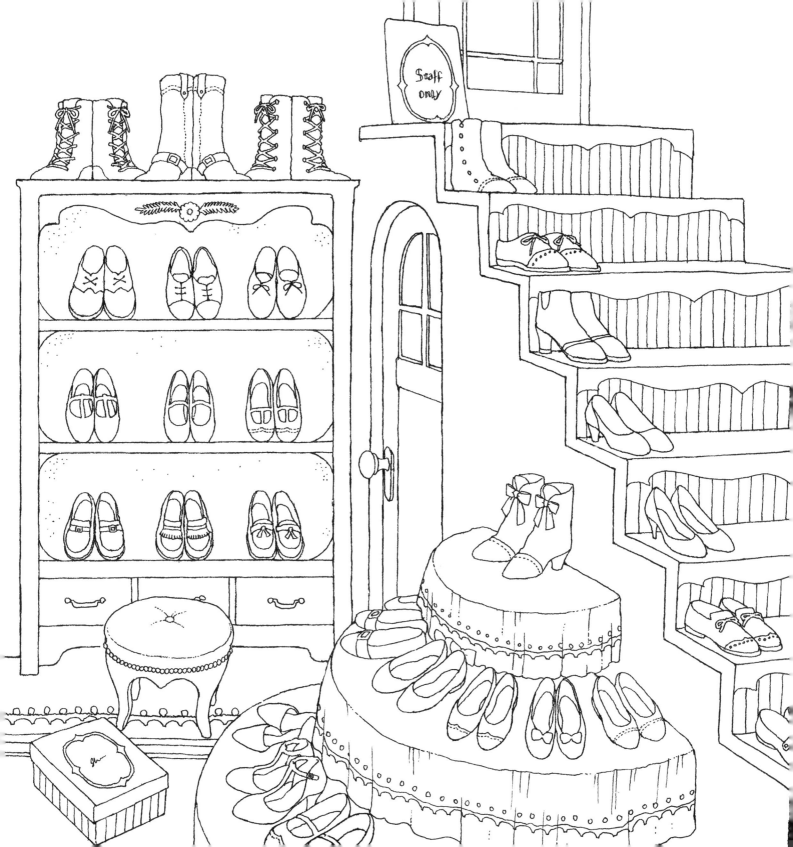

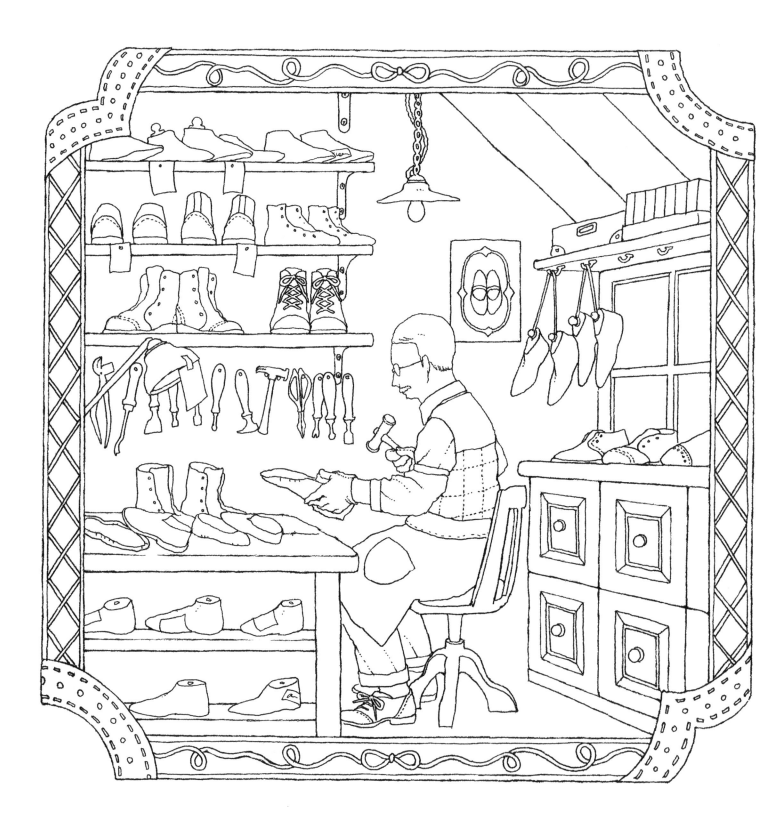

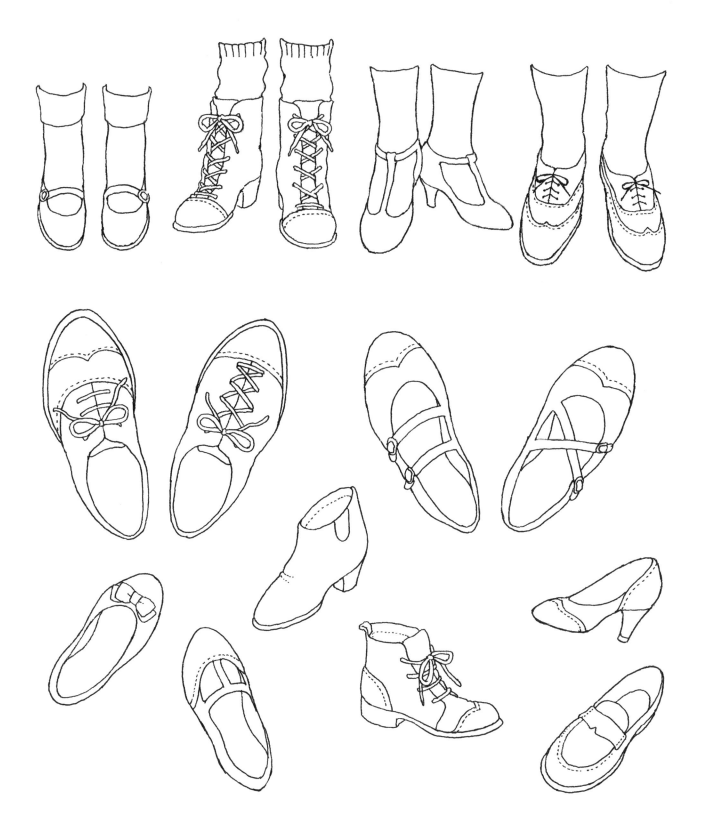

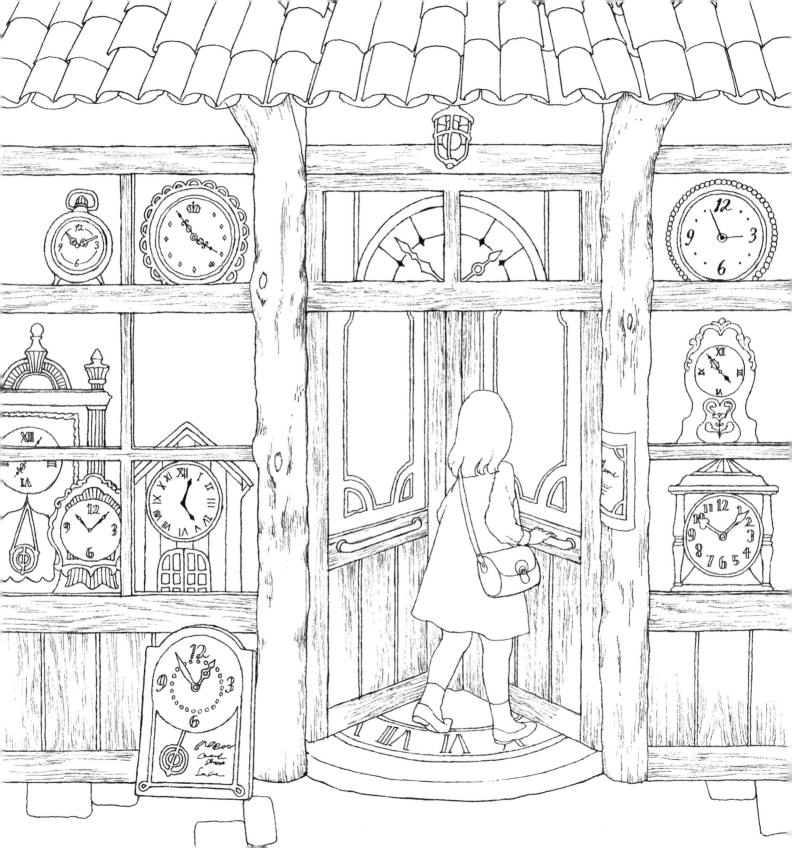

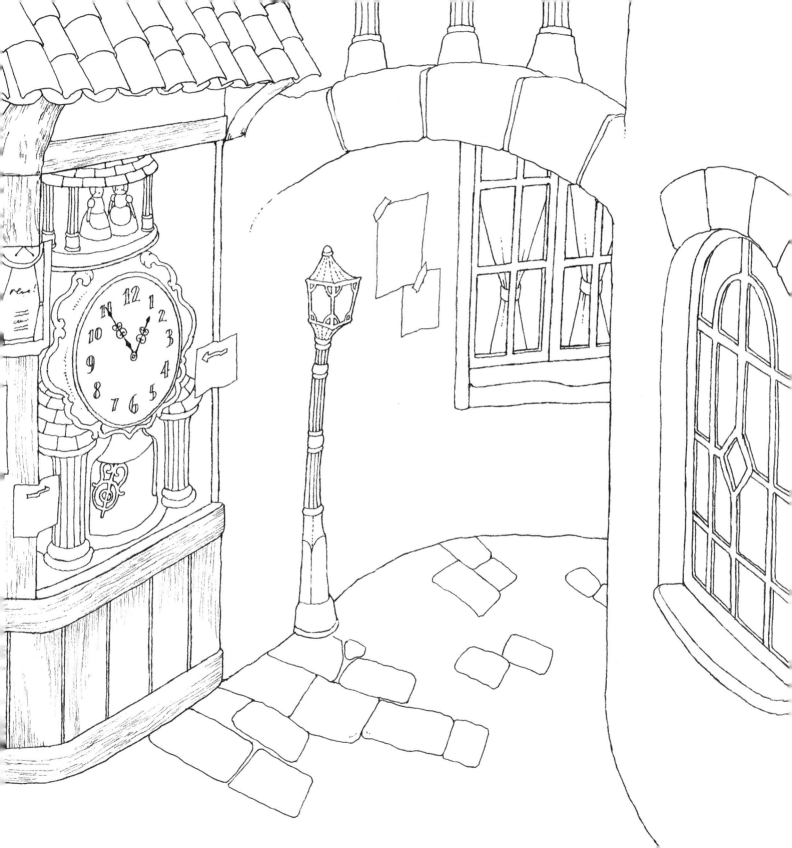

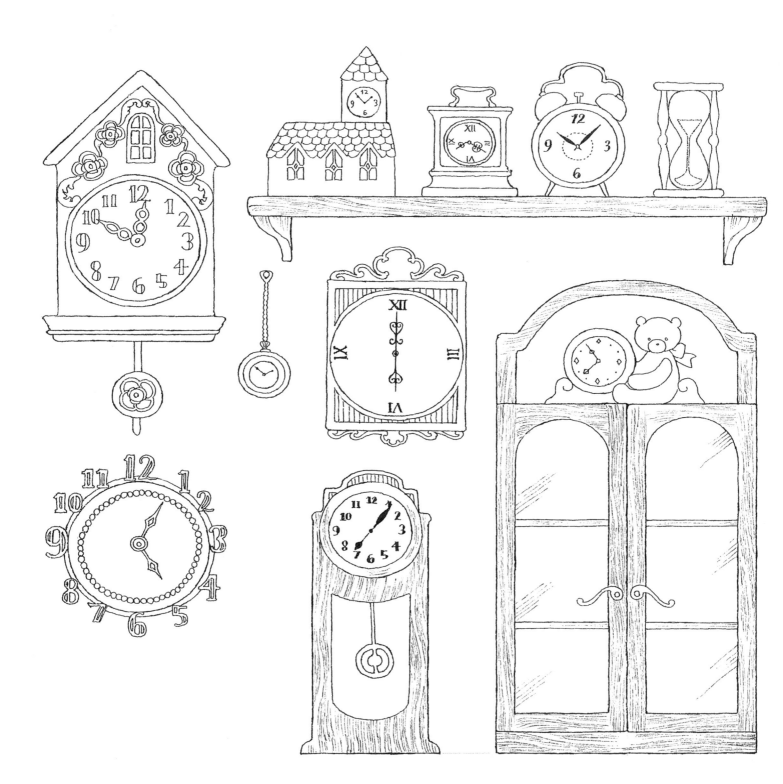

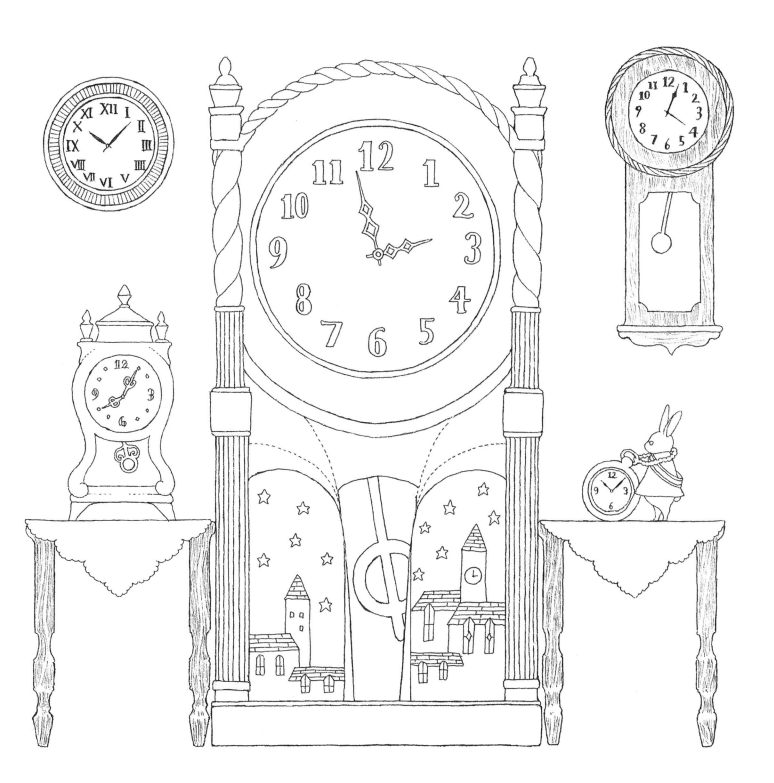

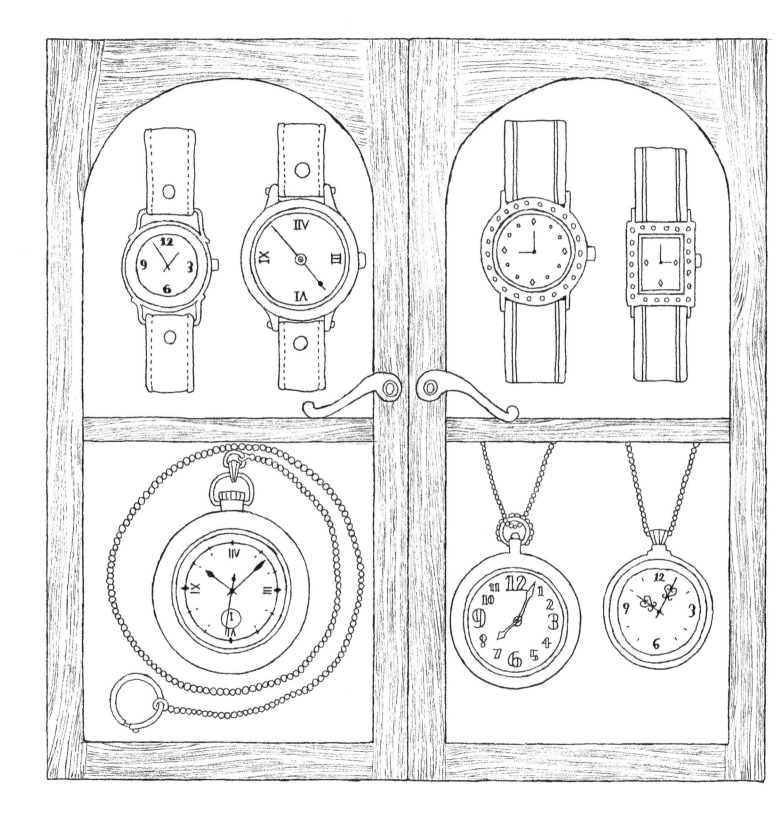

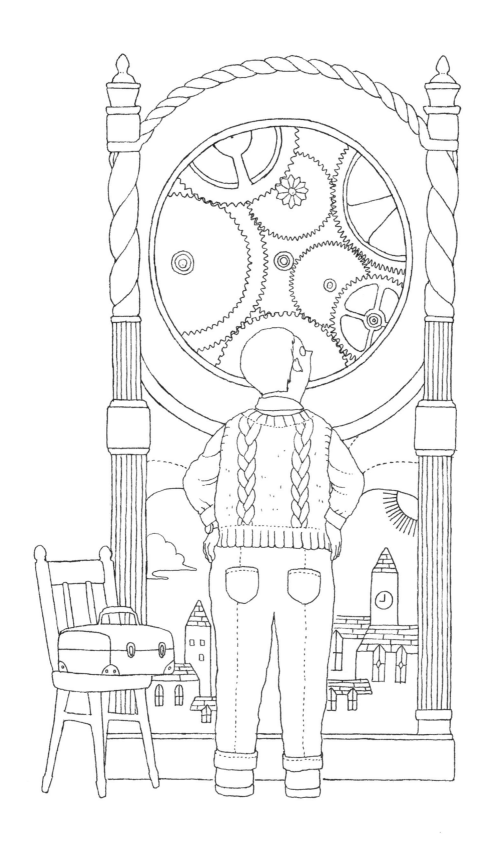

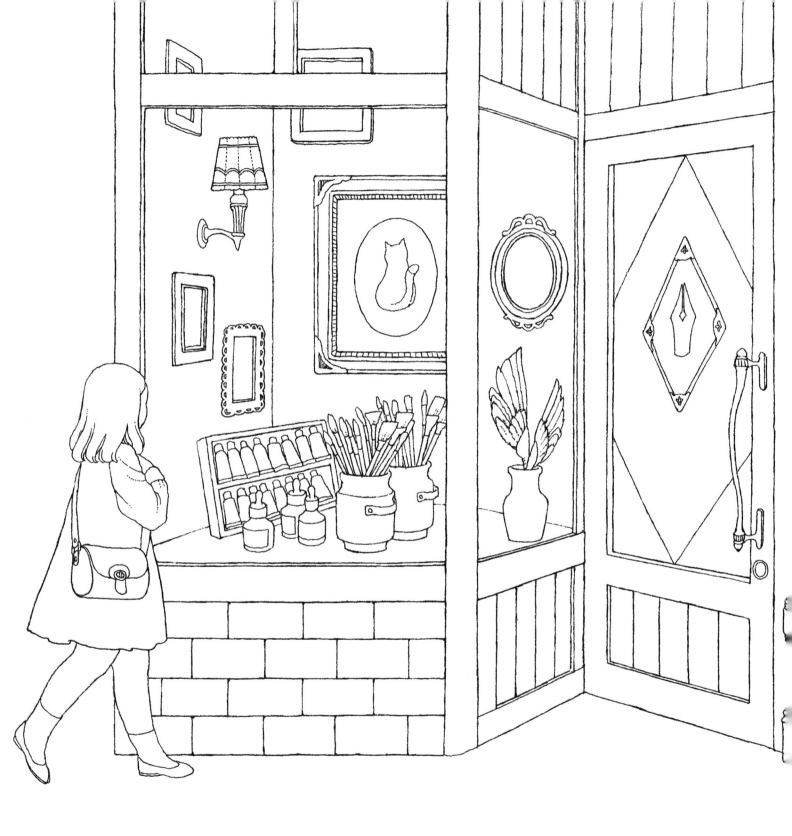

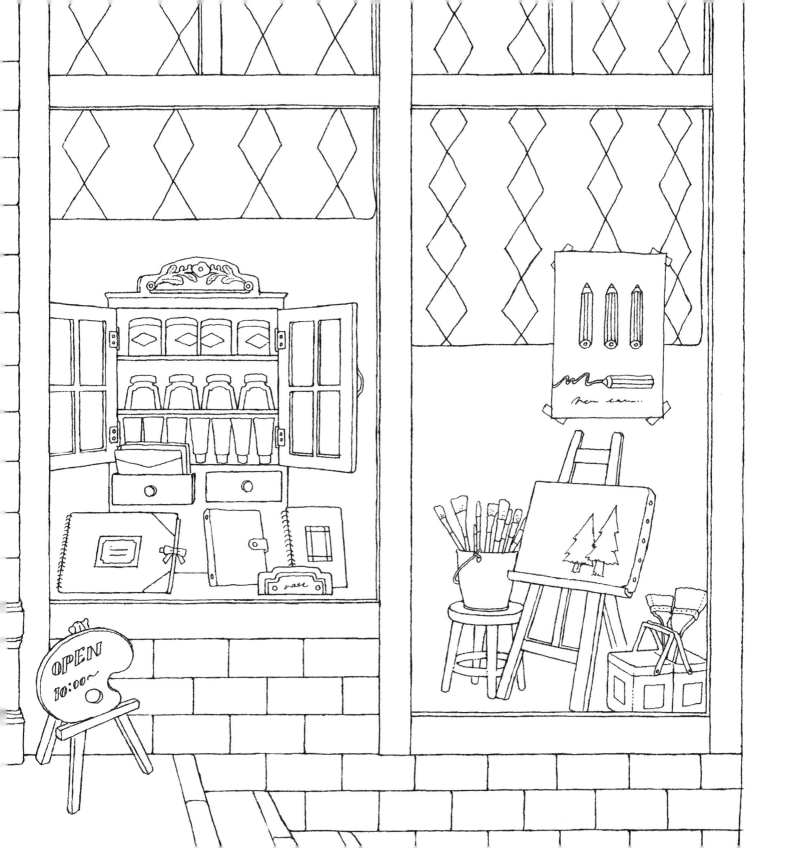

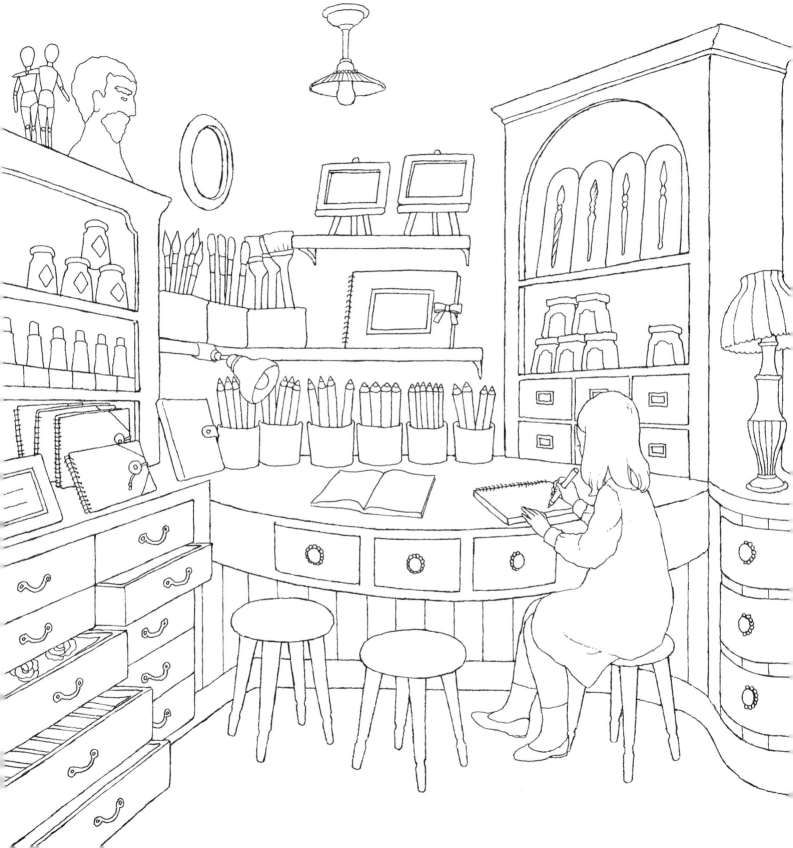

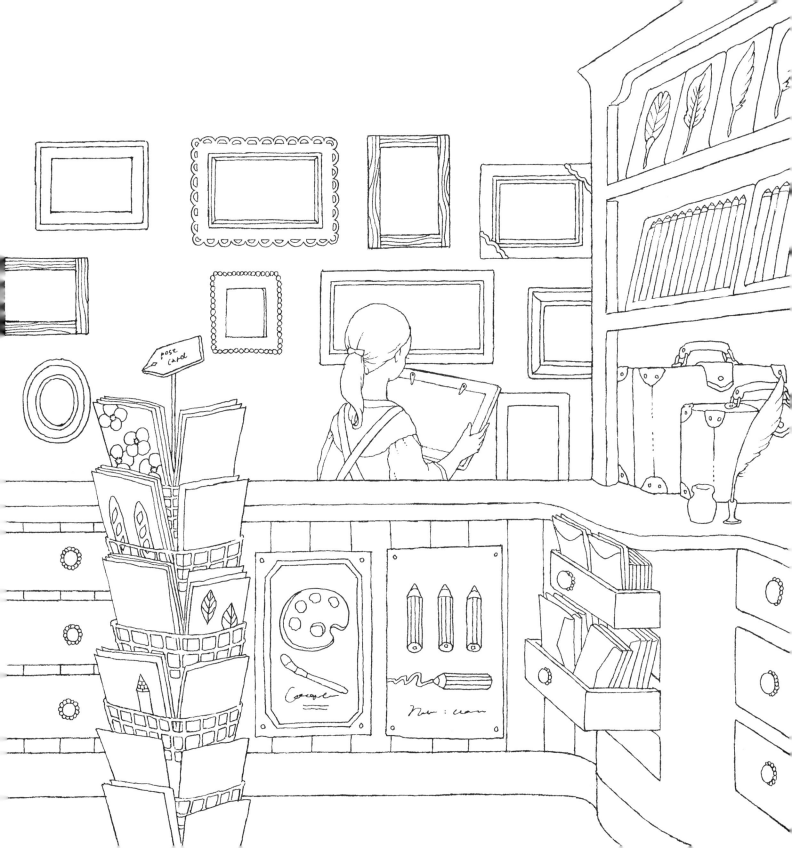

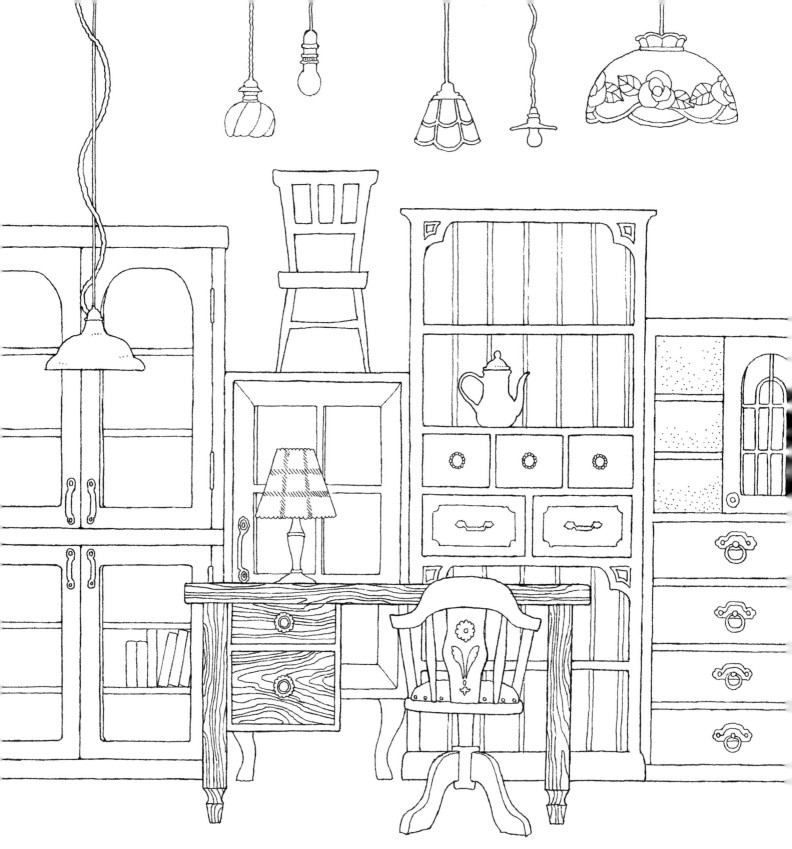

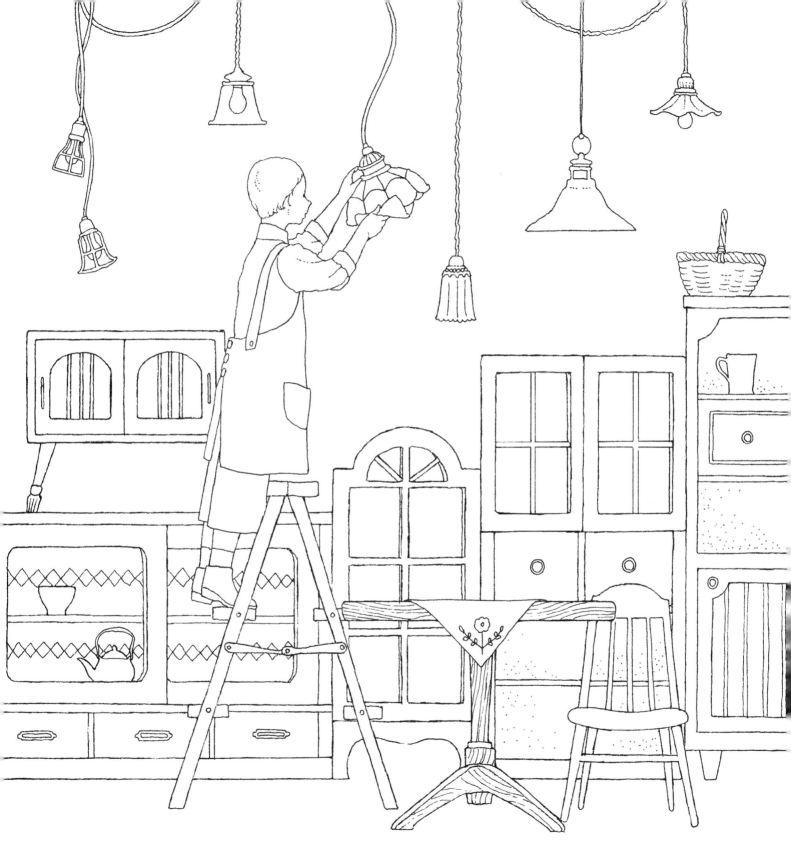

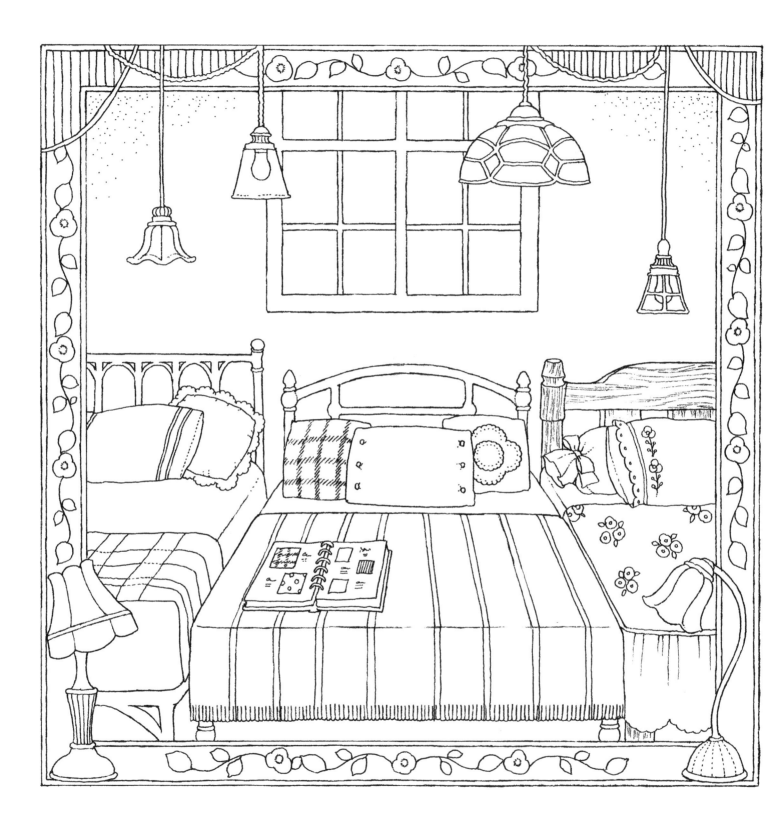

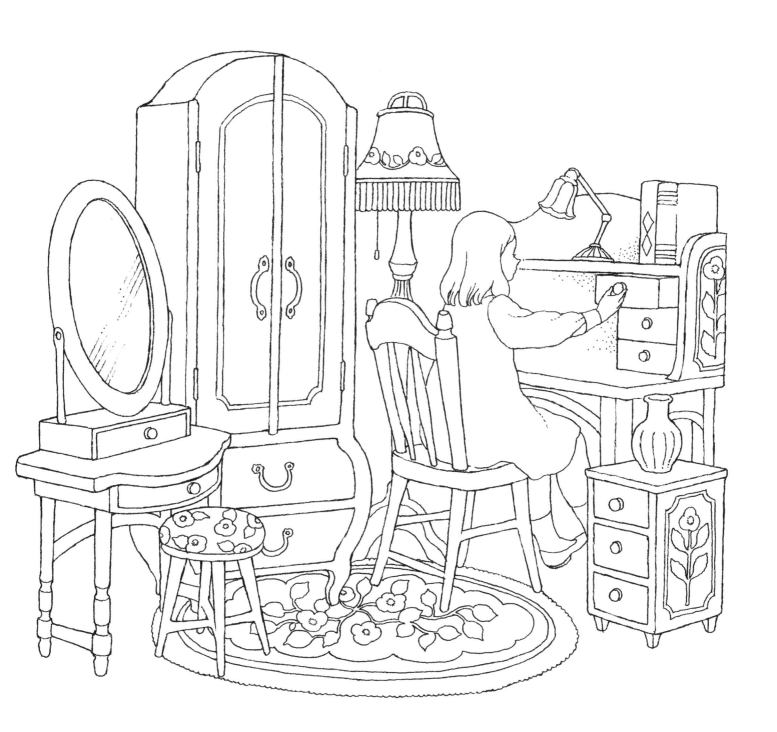

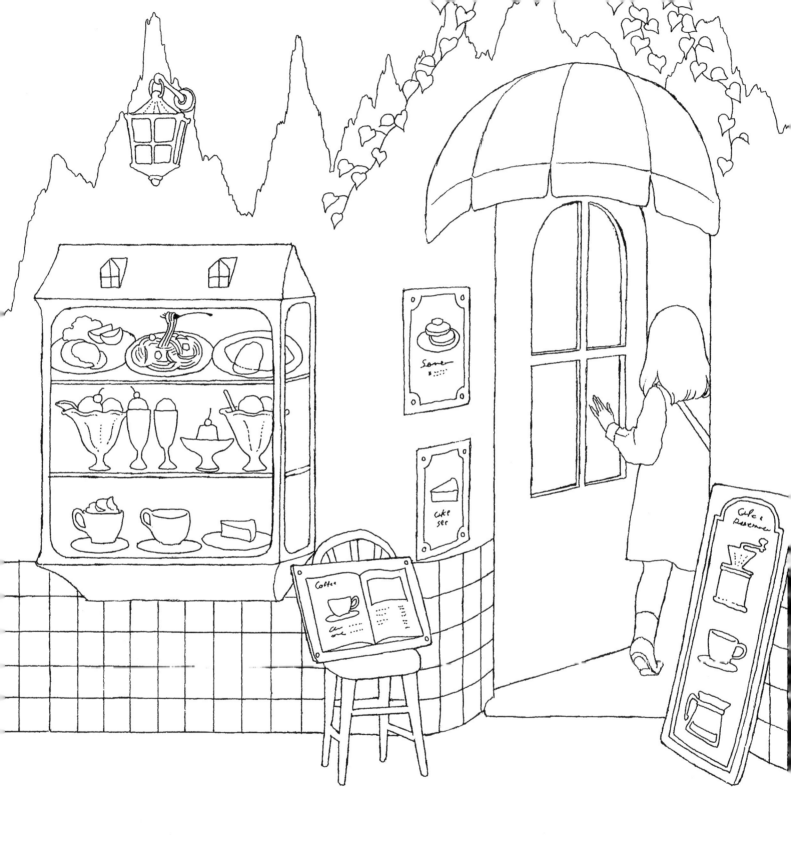

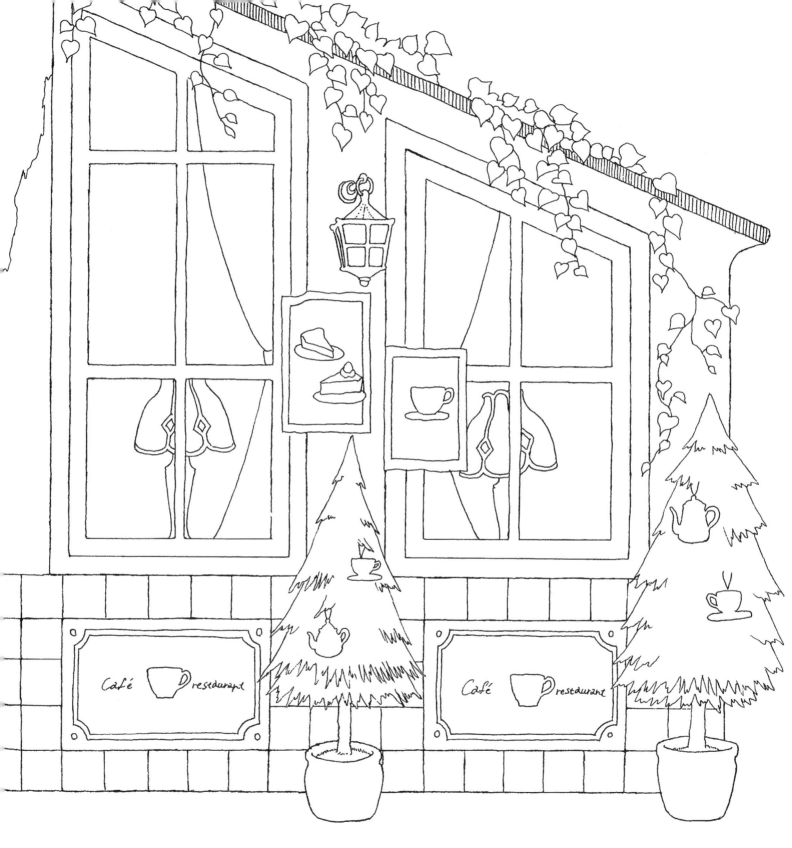

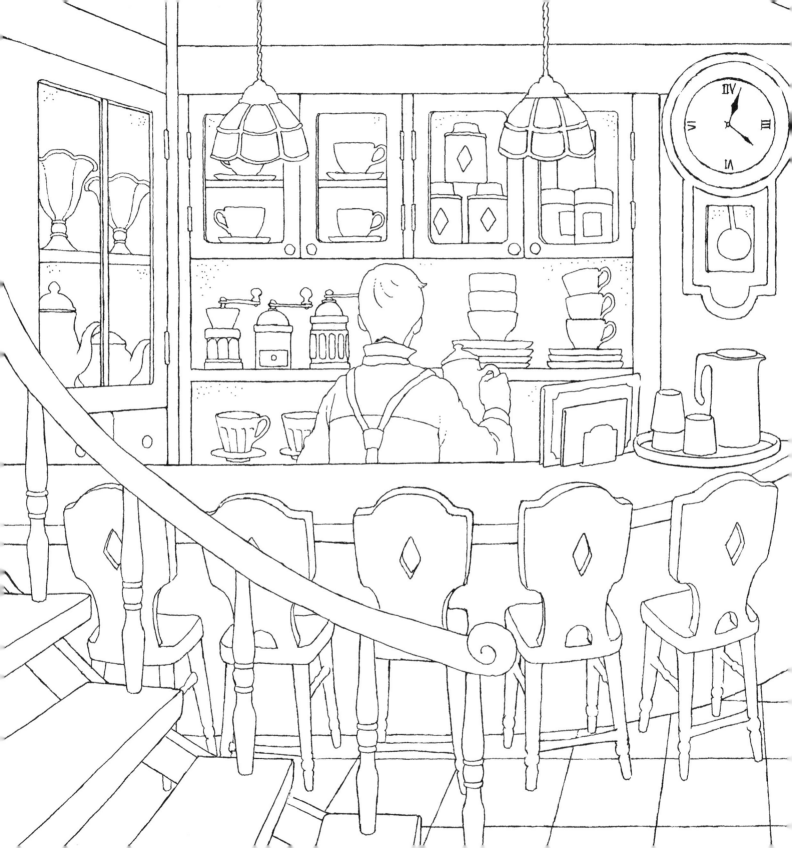

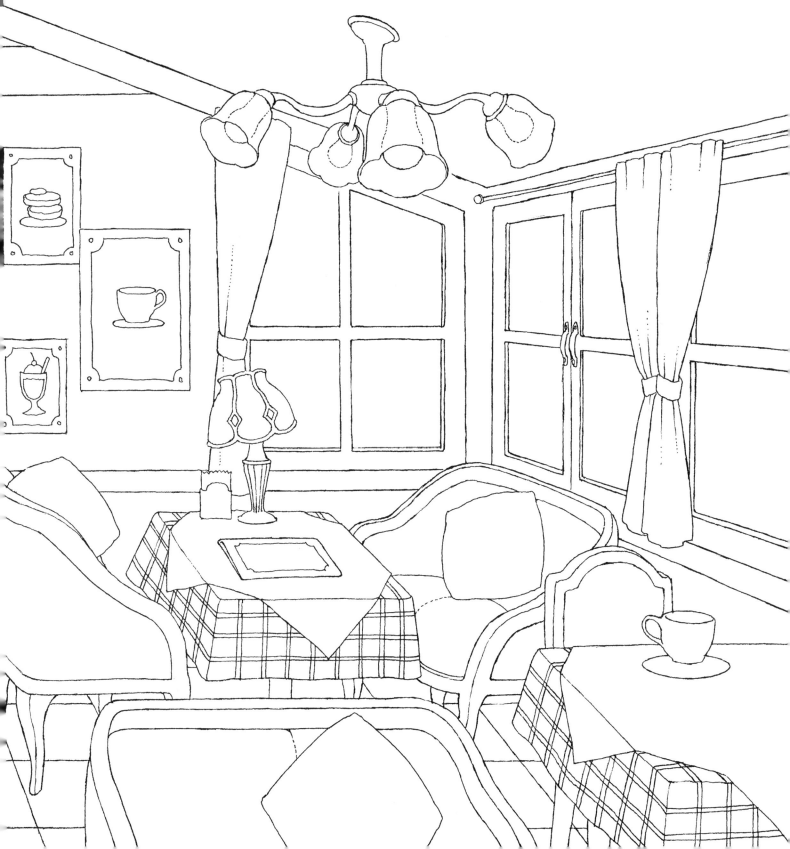

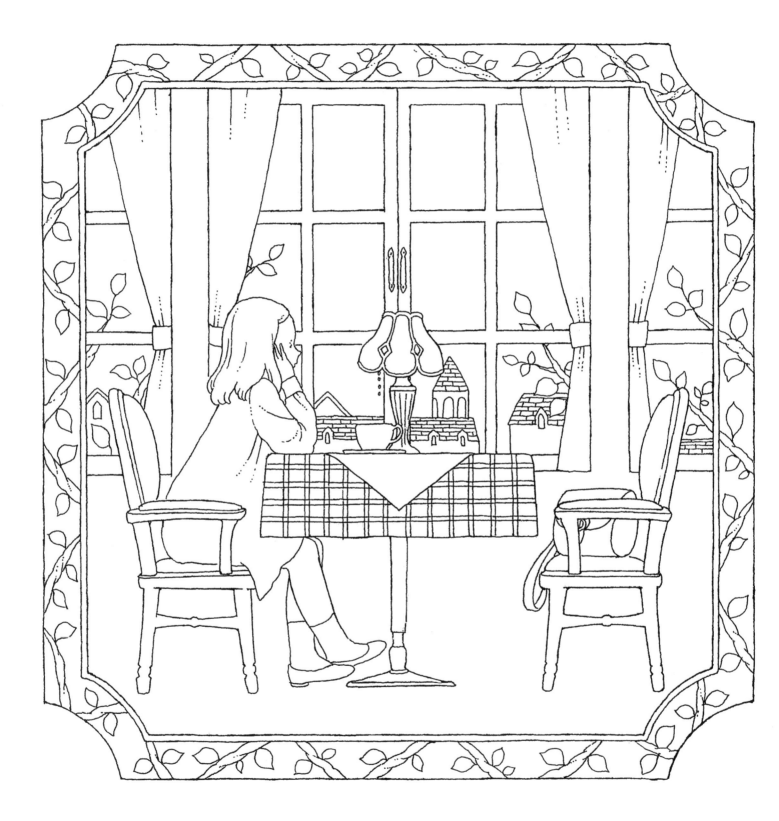

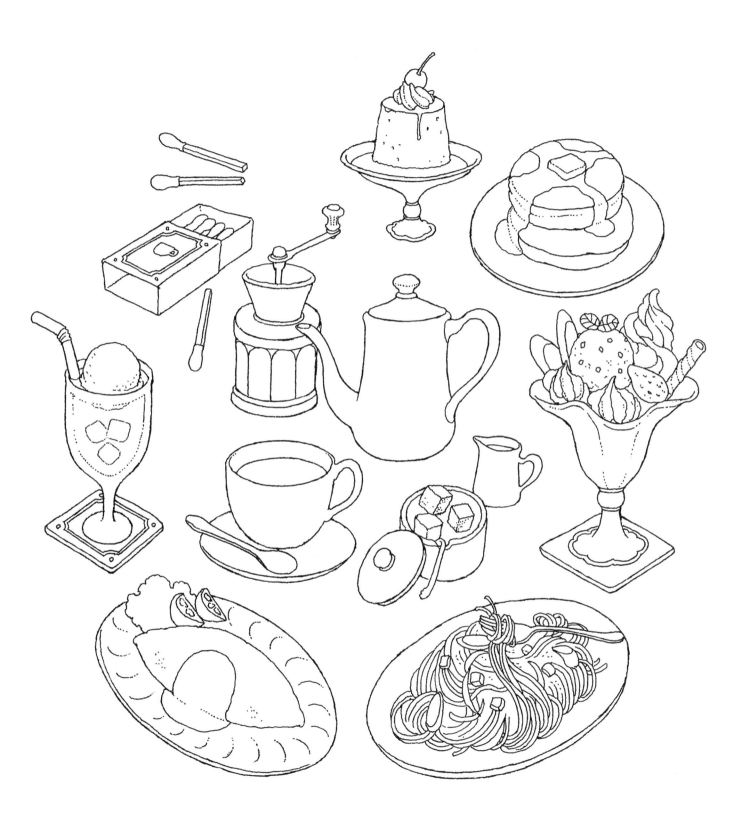

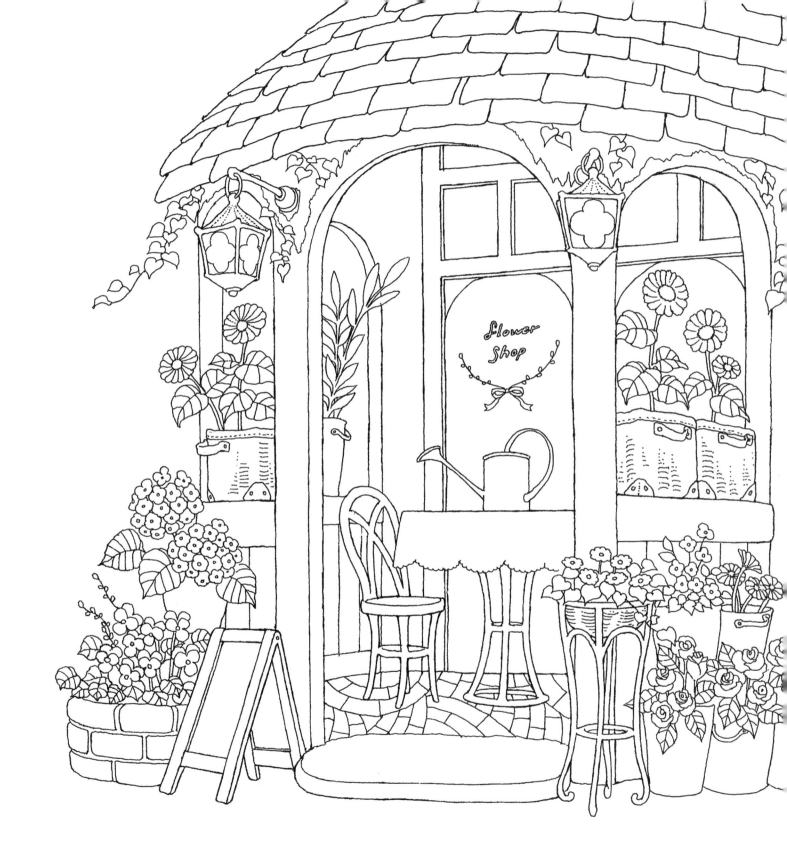

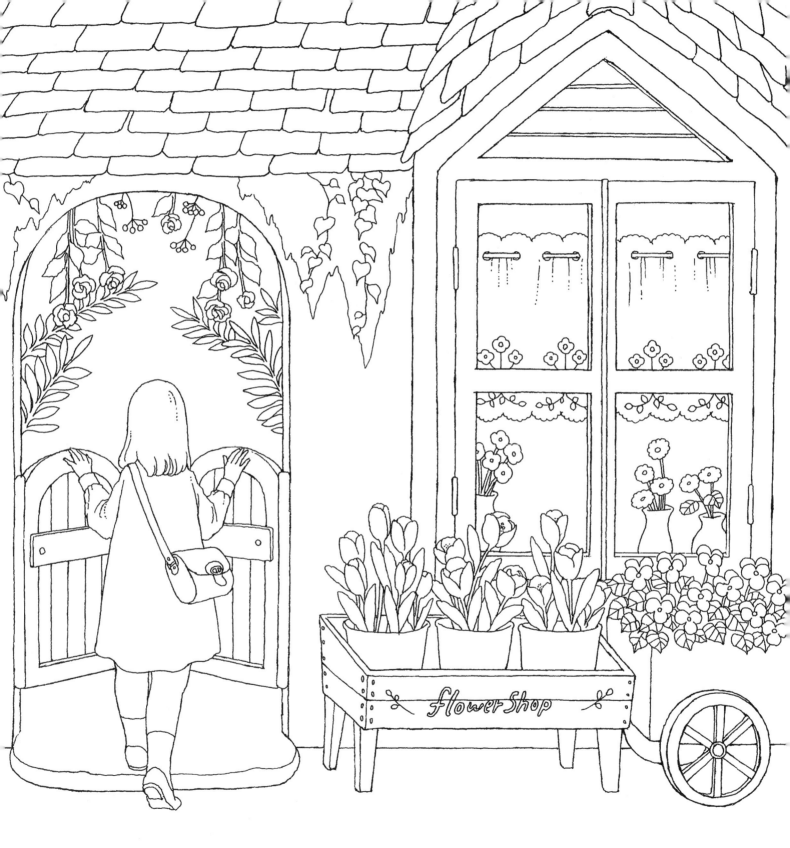

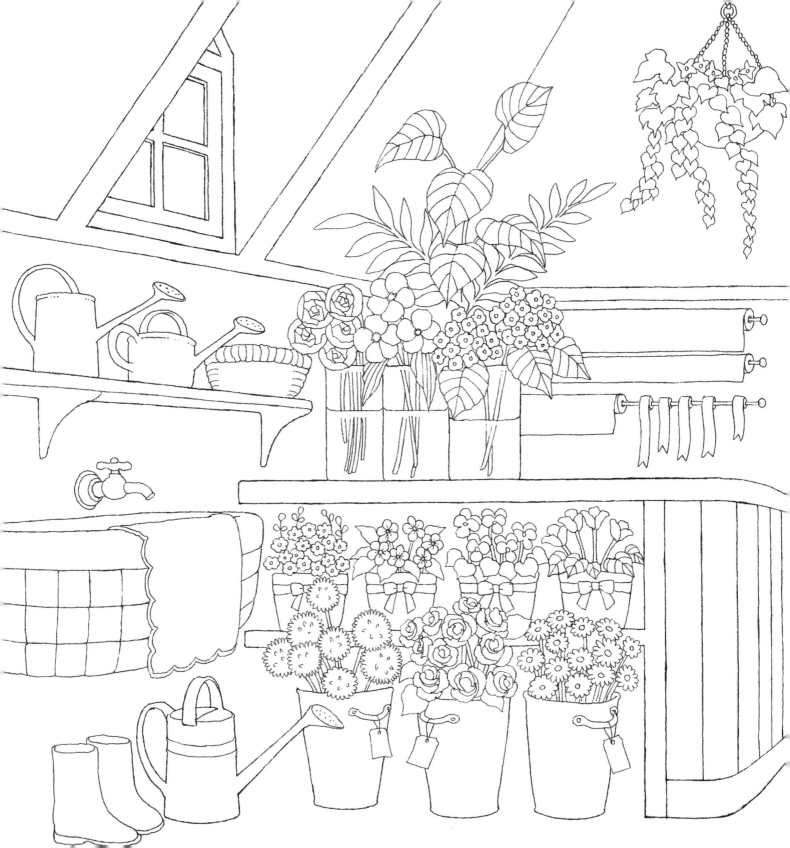

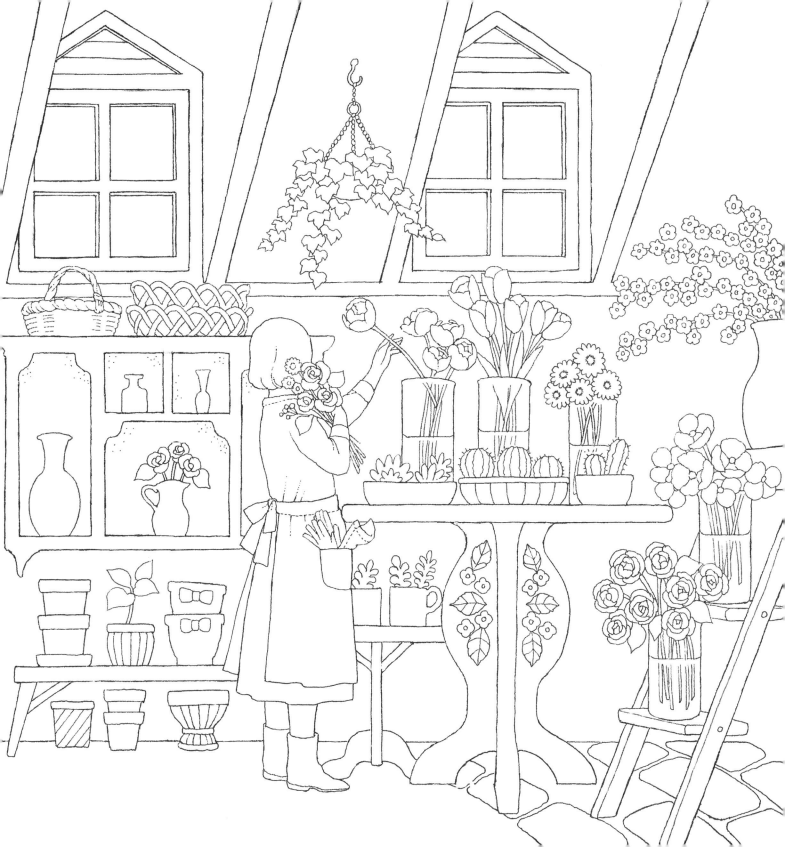

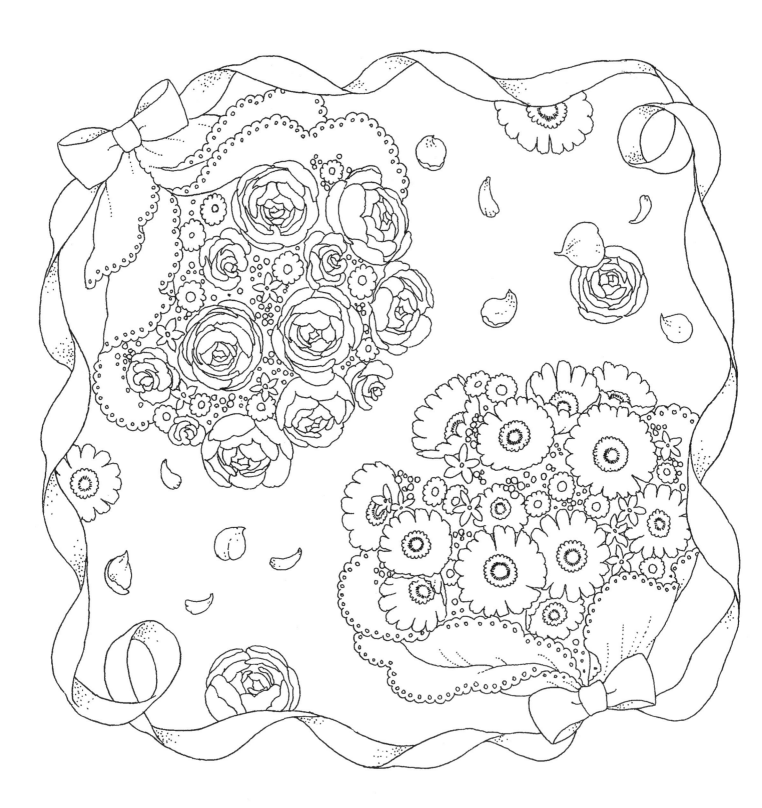

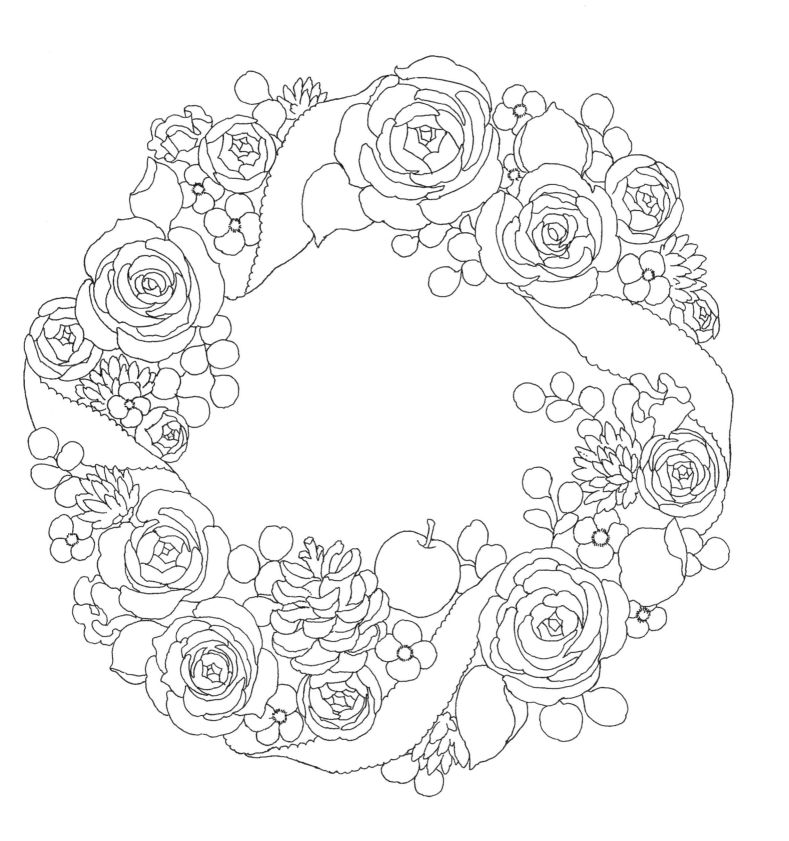

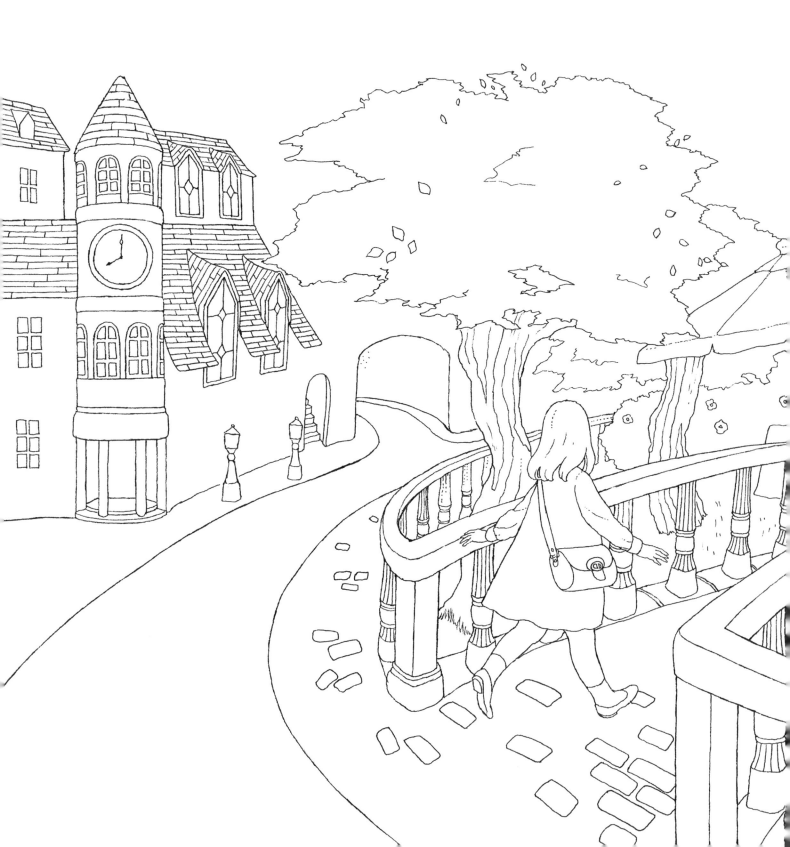

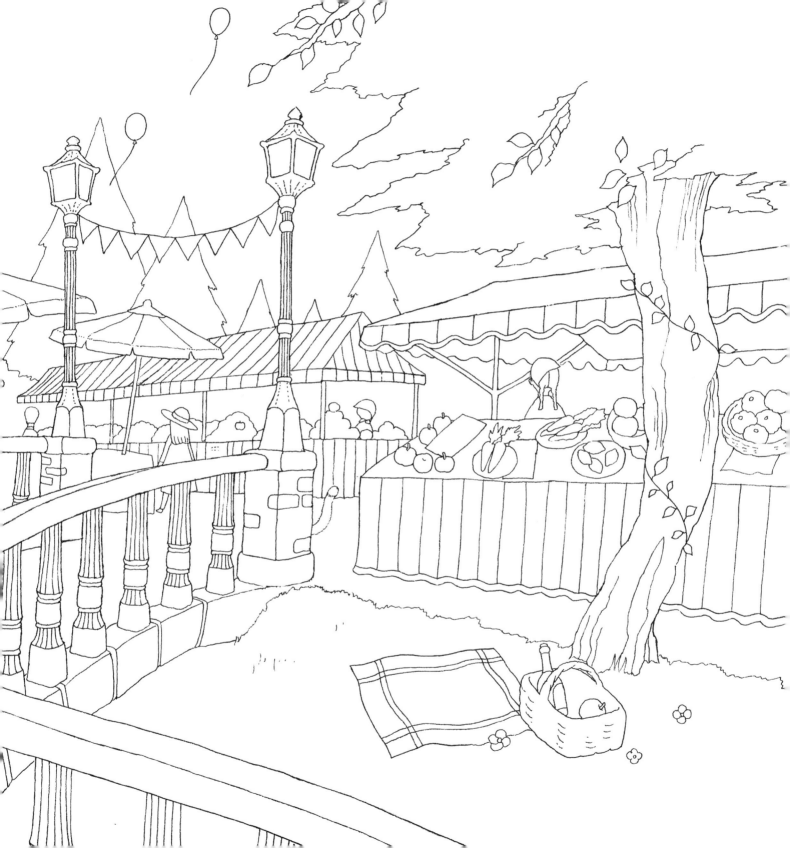

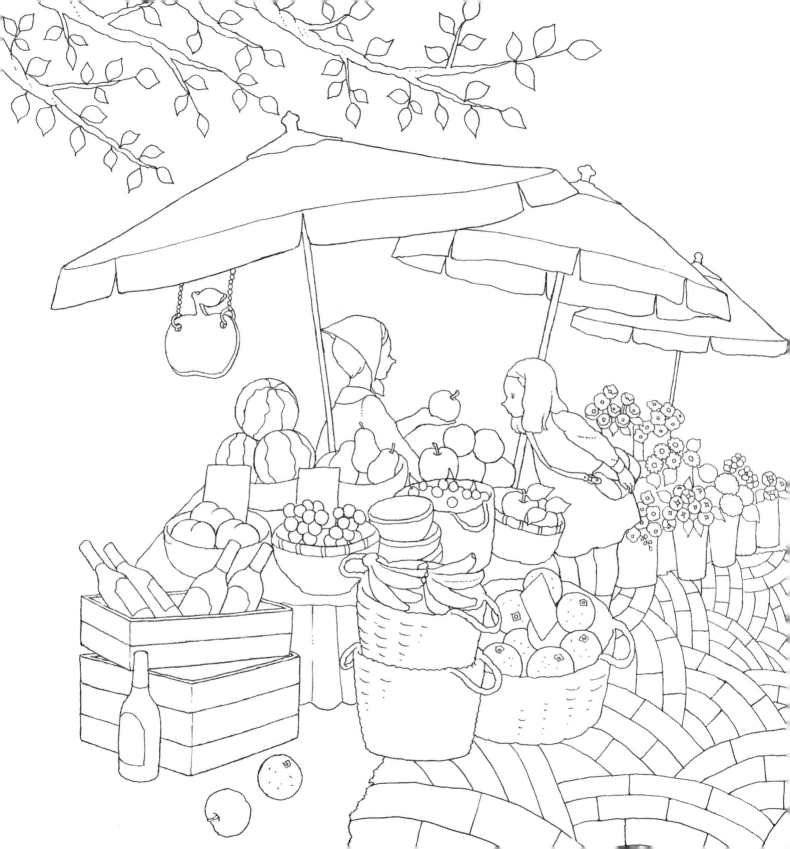

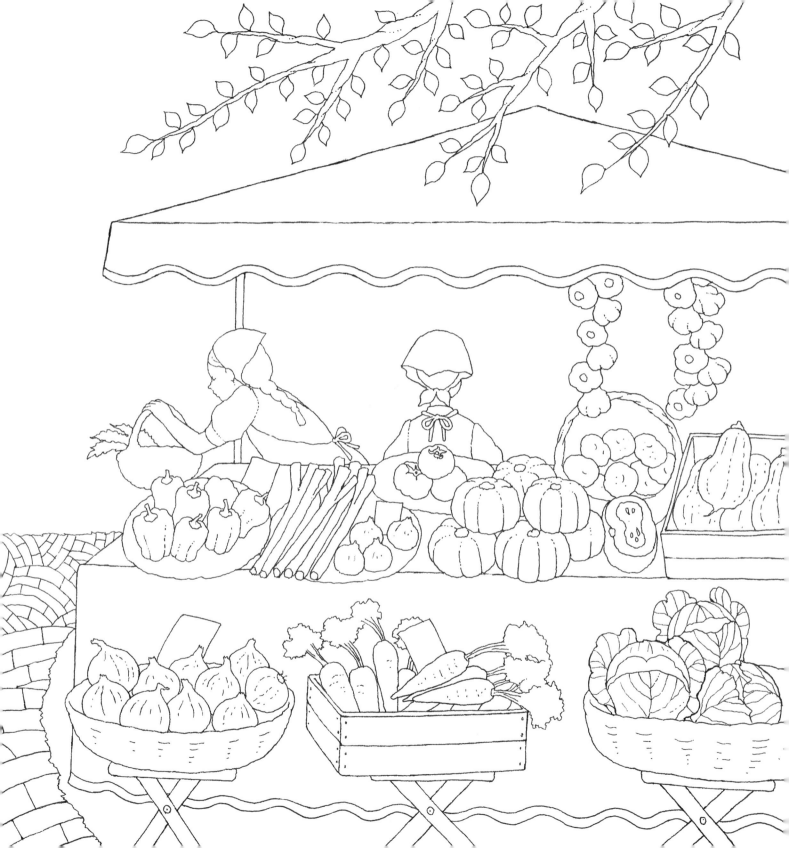

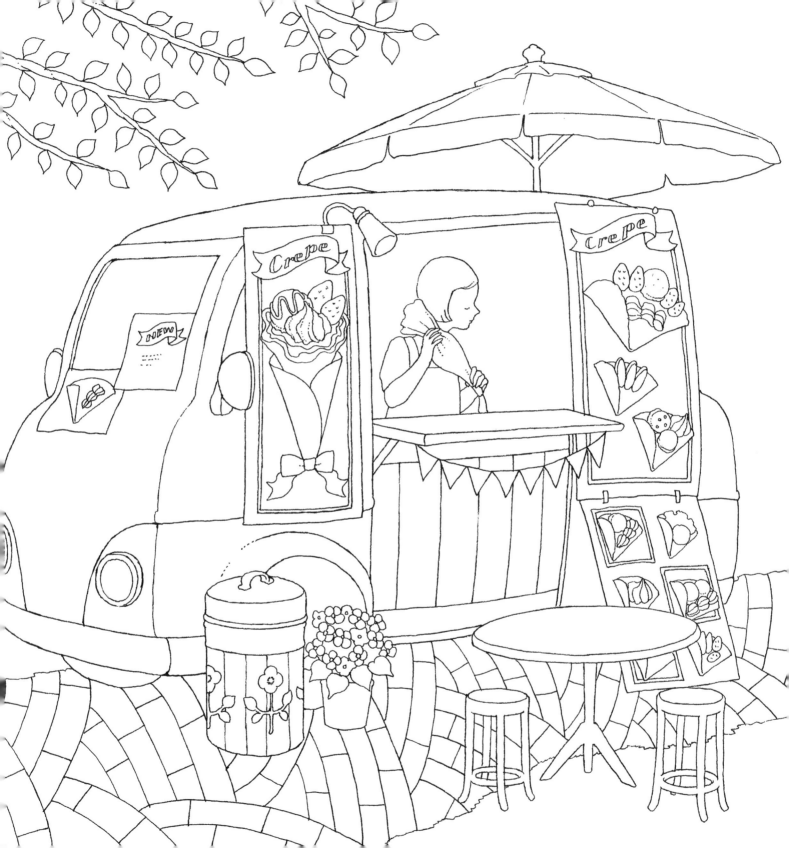

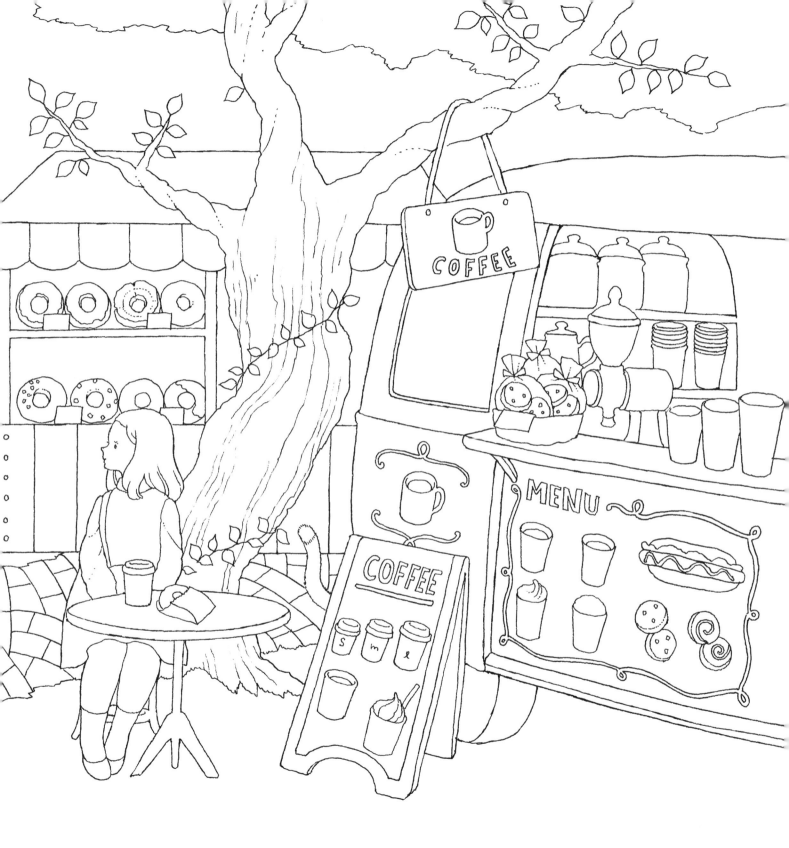

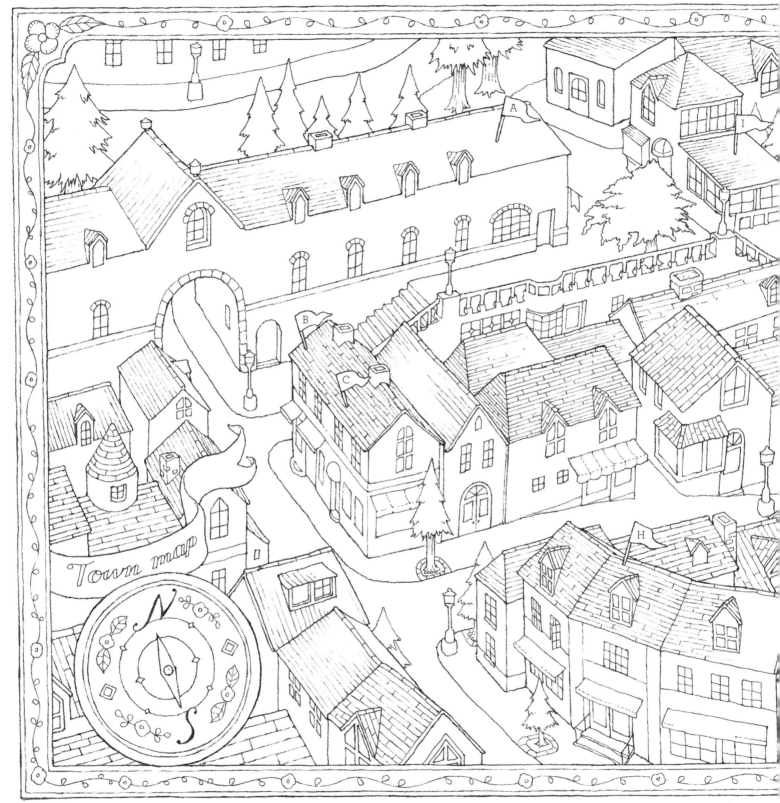

Town Map: A. Bookstore B. Bakery C. Patisserie D. Tailor E. Shoe store F. Clock shop G. Craft store H. Furniture store I. Cafe J. Flower store K. Farmers' market

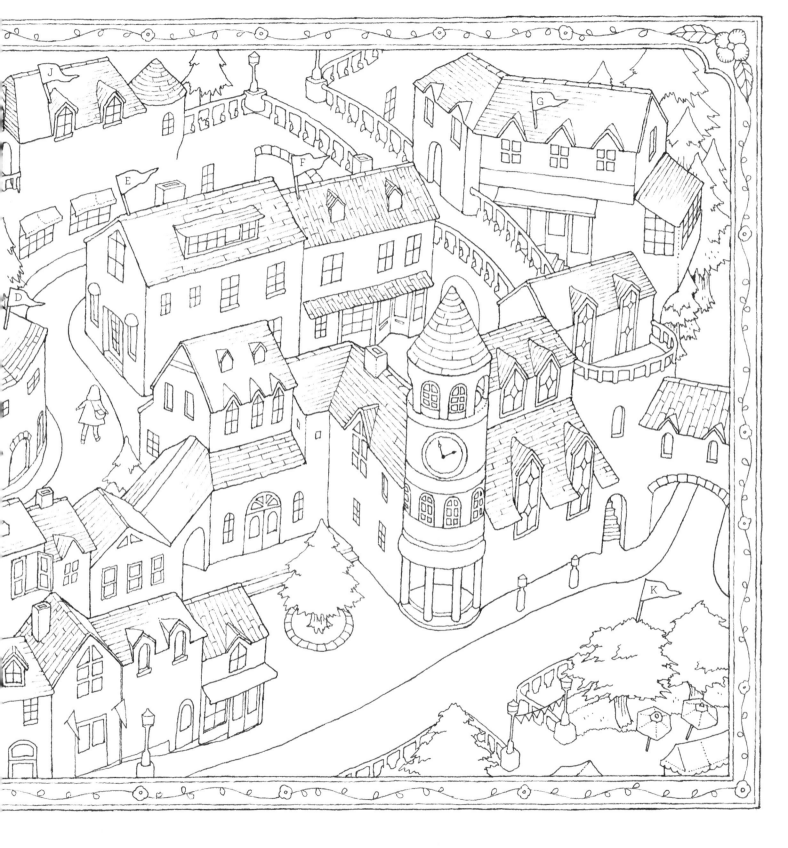

My Colorful Town
A Coloring Tour

ISBN: 978-1-942021-59-9

## About the Author

Chiaki Ida is a writer and illustrator from Japan. She is known for pen and ink drawings featuring nostalgic household scenes and children. She exhibits regularly in Japan. To learn more about her, visit chiakiida.tumblr.com

English edition first published in 2017 by Get Creative 6,
An imprint of Mixed Media Resources, LLC
161 Avenue of the Americas, New York, NY 10013

© 2016 Chiaki Ida/NIHON VOGUE-SHA
WATASHI NO NURIE BOOK AKOGARENO OMISEYASAN (NV70327)
Originally published in Japanese language by Nihon Vogue Co., LTD.
English language rights, translation, & production by
World Book Media, LLC
www.worldbookmedia.com
Email: info@worldbookmedia.com

Library of Congress Cataloging-in-Publication Data not available at time of printing.

Typesetting: Arati Devasher, aratidevasher.com

Printed in China

10 9 8 7 6 5 4 3 2 1